Retail Desire

Design, Display and Visual Merchandising
Johnny Tucker

RotoVision

For Josie, Ruby and Noah

Acknowledgements

First off, thanks to James Padley for all that
great typing! And to Christine Brickman,
Nancy Frick-Battaglia, Philip Morris, Matt
Moss, my editor Erica ffrench, and all at
Brinkworth, Conran Design Group and The
Echochamber—thanks for your help.

Retail Desire

Design, Display and Visual Merchandising

Johnny Tucker

A RotoVision Book
Published and distributed by
RotoVision SA
Route Suisse 9
CH-1295 Mies
Switzerland

RotoVision SA
Sales & Editorial Office
Sheridan House
112/116A Western Road
Hove
BN3 1DD
UK

Tel: +44 (0)1273 72 72 68
Fax: +44 (0)1273 72 72 69
E-mail: sales@rotovision.com
www.rotovision.com

10 9 8 7 6 5 4 3 2 1

ISBN 2-88046-806-X

Book design by Wayne Ford

Reprographics in Singapore by
ProVision Pte Ltd

Tel: +65 6334 7720
Fax: +65 6334 7721

From New York to Tokyo

Walk in off the New York sidewalk into a SoHo building and you enter a world of giant mannequins with clothes in cages roaming around 10 m above your head; step off the Paris pavement, into a store where the changing rooms are fields of swaying, corn-like glass fiber; open a door from the bustling streets of Tokyo, and walk into a world of kaleidoscopic, translucent geometric shapes containing the latest catwalk creations to hit Japan.

A common thread runs through all of these very different stores—they're all out to stimulate you into buying something. They are trying to create within you a strong retail desire.

While all these stores' efforts are aimed at getting you to buy something, it's not quite as simple as that. Sales and bottom-line performance are by far the most important outcome of retail design, display and visual merchandising (VM), but there's a lot more at play here. Lifestyles are promoted, stories are woven, eye-catching, head-turning, even stomach-churning, material is used to give life and a depth of cultural meaning to that essentially bland word, the Brand.

The stores mentioned above are Prada in New York, an emporium, which is part shop, part theater (literally and figuratively); Mandarina Duck in Paris, which uses concealment as a way of stimulating interest in the product; and finally, the Christian Lacroix store in Tokyo, which, while more traditional than the other two, uses the very latest glass-laminating techniques for striking, sculptural display units. You can read more about all three of these projects in the Contrasts section of this book.

These projects are all clothes stores but, of course, design display and visual merchandising extend far further than fashion, even in its broadest sense, taking in all those products which go into making the picture-perfect lifestyle. Step through the doors of a store filled with Fast Moving Consumer Goods (FMCGs), like a supermarket for example, and you're in an altogether different environment where a plethora of similar products vie for your attention and displays adopt very different methods of driving your focus to their target product. In this world, sales really are king; it's about shifting units in large quantities—in the nicest possible way, of course. While this book occasionally touches on FMCGs, it concentrates largely on the other sector.

"Our approach is to keep it simple and not too serious—there's already so much stuff vying for your attention as you walk down the street, not to mention other things to think about, like your love life, did you leave the oven on?, work, money, etc...."

Lance Martins, Paul Smith, on the brand's approach to window dressing

What exactly is visual merchandising, and when does it turn into display? Another interesting question which arose during the writing of this book is exactly who is responsible for visual merchandising?—ie the act of creating an environment, whether it's a whole store interior, a store promotion scheme or a window display. The answers to both questions vary massively, not only between sectors but within them.

Ask one person what visual merchandising is and they'll tell you "store windows": beautifully dressed mannequins behind huge plates of glass acting as huge, immediate advertising billboards for the products right behind them. (That's one style of window dressing, but there are a million variations.) Ask another person and you'll get an answer that includes the windows, but also takes in the entire in-store environment and may even go further into the realms of graphics, audio-visual media, point-of-purchase material, all the way to the store as the total embodiment of the brand—the 3D brand. And so often designers and architects create store environments which are heavily prescriptive in terms of display.

Take Future Systems' work for Italian fashion retailer Marni (pages 38–9) as an example: "The spirit of the shops has been generated by the clothes themselves—textures, color, composition and beauty in nature are the inspirations for this response. We attempted to create an interior landscape. The clothes become a part of an overall composition, not separated from the design of the space but part of it." The display system is an integral part of the store itself and the only real room for maneuver is in the choice of clothes and the order they are presented in.

Pretty much every retailer will also have a different, subjective definition of, and delineation for, where visual merchandising ends and display takes over. But strip it down to its bare essentials, and display and visual merchandising—however you break it up—is about presenting a product and any supporting material in the best possible manner so that it evokes as strong an empathetic response in the consumer as possible. This encompasses everything from dramatic, attention-grabbing window display, through to product display and positioning within store, and elements such as how you draw and guide a customer through the store and the environment itself, right down to the finishes. What's more, it all has to be bang on brand.

"Using a mannequin is about creating a fun environment, expressing the attitude of a department store or shop."

Ralph Pucci on mannequins

"People don't shop for commodity anymore. We are employing architects with vision because we have to design something that will still be working in fifty years' time."

Vittorio Radice, Selfridges, on the future of shopping

"Visual merchandising can be seen as an essential component of brand creation and evolution," says Erwin Winkler, US creative director at display manufacturer Alu. "It's fast assuming equal importance to a brand's success on a par with advertising."

This is echoed by Christine Brickman, of UK mannequin company Proportion London, "The visual merchandiser should always have one eye on the business, watching absolutely everything and making sure that it's all giving the same message and building towards the impact of the brand in every manifestation."

Talking to retailers around the world I found that the point at which visual merchandising becomes display is often an operational division, one that helps sort out manpower and responsibility issues. And this is where things get really complicated—who is responsible for it, who is in control? Is it the visual merchandising manager, is it the display manager, the creative director, brand manager, managing director or the CEO? Or is it the design consultant or architect who creates the 3D environment? The answer is… all of them, to varying extents.

This is something any supplier knows well: "No one retailer is set up the same as the next," says Christopher Jenkins from Vizona, the Germany-based display specialist. "Sometimes when you work for a retailer your visual merchandising contact is all powerful. Then you go to the next retailer and it is the store-development director who is all powerful and at the next, it's the CEO."

Visual merchandising and display is the hard-nosed world of retailing at its most visceral, and while it is tempting to think it's about what looks good, in truth there is far too much money invested in retail to allow for such subjectivity. Phrases such as "product density," "units per customer," "buy ratios" and "thresholds" are all stock terms in a professional industry that has developed benchmarks and ways of measuring its performance. There are even companies which use pure science—NASA-developed eye-movement tracking equipment for research to form the basis or the starting point for design, display and visual merchandising decisions.

That said, this industry, like design, marketing and advertising, which form part of the visual merchandising and display mix, is all about the fine art of persuasion. Measuring its efficacy is far from an exact science and the human factor, gut feeling, creative genius, experience and knowledge learned on the job look set, for the foreseeable future, to play a major role in shaping how those in the industry go about stimulating retail desire.

"Accepted retail philosophy says that you have to have a window display. It also says the entrance should be central. We didn't do that, yet it all works far more powerfully to communicate something about the brand and its values."

Adam Brinkworth, Brinkworth, on Karen Millen, London

Contrasts

Take a trip down any high street, along any shopping center mall and you see that while the stores are all trying to sell you something—and most of the time there's little to tell their stuff apart—they're all doing it using contrasting styles. This chapter examines how retailers are doing the same thing, but in very different ways.

While many of them are stacking it high and selling it cheap, making you sidle between rows of brightly colored wares, at the other end of the scale, you can walk into a high-end fashion store and the clothing is dotted sparingly about the interior landscape.

What much of it boils down to is brand and brand values. Is that brand about volume sales or is it about selling you a lifestyle? It is not often as clear cut as that, with many brands combining both approaches. For example, Levi's (pages 30–5) sells the brand and lifestyle in its flagship and individually designed stores, while also looking for high-volume sales in the high street using different retailing techniques.

There are many constants in stores that everyone has to work with, such as fixtures and fittings. Every retailer needs display units of some kind, and lighting. Here the approaches are as varied as the retailers, ranging from totally bespoke solutions for all aspects of the design to an off-the-shelf style of shelving, and all the permutations in between.

Retailers have long been guilty of lighting their product with very harsh levels of lighting. But times are changing, with designers often now leaving the lighting to specialists and even lowering the levels—lingerie specialist undressmetili.com (pages 58–9) for example, which has taken a boudoir approach to lighting.

Massive competition within the retail sector demands continual market differentiation, updating, design evolution and occasionally revolution. Change is one of the true constants in the retail world, albeit within brand parameters. And this continuous change and thirst for the new means designers and visual merchandisers are always on the look out for the latest new material, or indeed new ways of using tried and trusted ones. A good example of the latter is the sumptuous leather-clad Mulberry flagship store (pages 84–7). Taking leather usage to new extremes, it also plays on the heritage value of the material building up the "historical/traditional" cachet of the Mulberry brand, which is in fact little more than thirty years old.

Trying to reinvent the wheel in this way is one of the mainstays of visual merchandisers today, who often have incredibly similar basic tools, products and environments to deal with—although of course wildly differing budgets—yet manage to keep coming up with something fresh. They must find a style that contrasts with other stores while continually injecting life and energy into their own oeuvre. This is no mean feat when commerciality must always be a part of the equation.

Science or art

Visual merchandising and display have essentially grown up in a haphazard way, from market stalls to multinational, multisite retailing. As it has turned into a hugely competitive, multibillion dollar industry, retailers have begun to demand proof of the role visual merchandising, display, and design have to play and how to maximize their benefits.

Tried-and-tested methods, good business practices and, latterly, formal educational courses have developed, and even scientific research (rather than statistics) is being used to give the industry an edge.

ID Magasin, retail design and research specialist, has developed techniques to see exactly how shoppers shop, using video and eye-tracking devices to see what shoppers are looking at. From its data, it has discovered shopping is shopping the world over; it's a very homogeneous exercise. "Shopper behavior varies very little, not only within Europe and the US, but across the Far East and Middle East. Apart from some small cultural influences, essential shopper behavior remains exactly the same," says founder of ID Magasin, Siemon Scamell-Katz. Knowledge of the way shoppers behave is also augmented by a long history

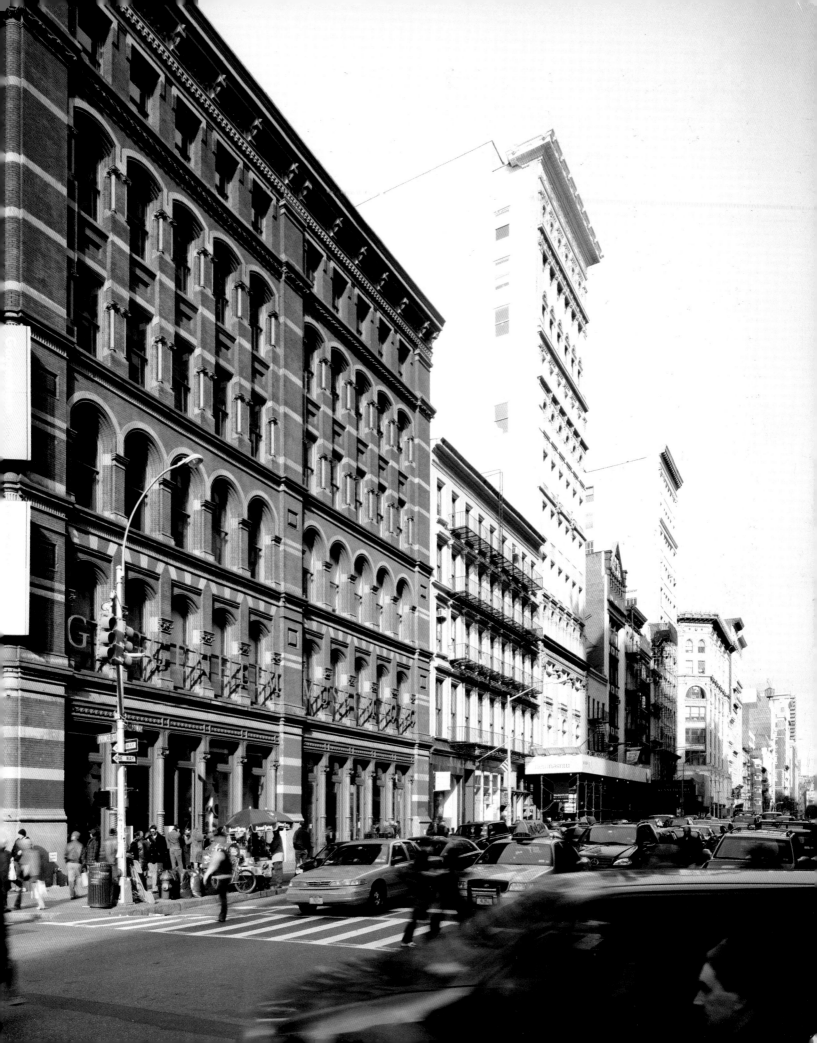

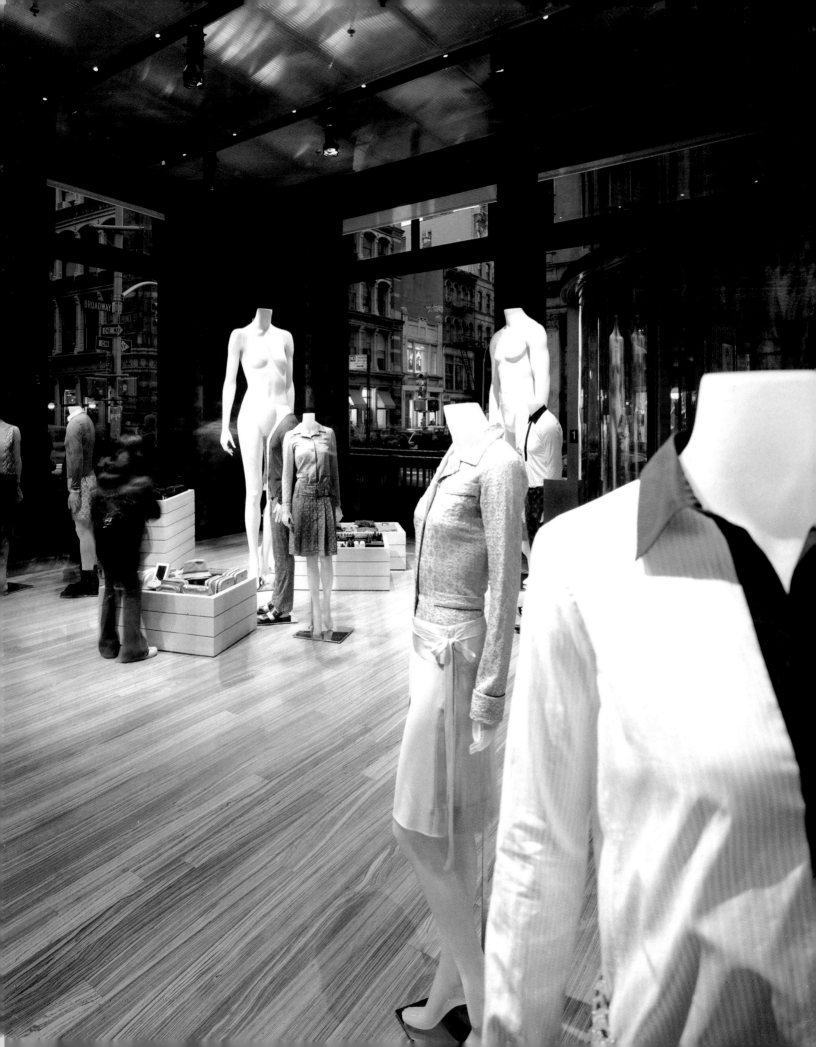

Prada, New York

There's been a certain verve and swagger to the Prada brand for some time now. The company knows it's at the forefront of fashion—or is perceived to be—and has the guile to call its 2,300 sq m retail offering on Broadway the "epicenter." It was never going to be just another fashion retail outlet.

Back in 1999, the Office for Metropolitan Architecture (OMA) was brought in by Prada to spend two months looking at ways to "reinvent retail." It obviously found a way as far as Prada was concerned because it was commissioned to create three US stores—the New York offering with Dutch architect Rem Koolhaas.

OMA project director and lead designer Ole Scheeren explains: "At a time when commercial activity has invaded all public spaces and cultural institutions, this concept offers a redefinition of exclusivity: the possibility for public functions and programs to reclaim the territory of shopping.

He continues a little more obliquely: "The commercial function is overlaid with a series of experiential and spatial typologies: Clinic—an environment for specialized personal care and service; Archive—an inventory of current and past collections; Trading floor—an accumulation of rapidly changing information, new technology applications and e-commerce; Library—zones of content and knowledge dedicated to the evolution of the fashion system; and Street—a space for multiple activities, liberated from the pressure to buy."

In keeping with the theme of culture reclaiming retail territory, is "the wave," which links the street-level space and the basement level. It's a wave-shaped, zebrawood slope, which can be reconfigured to create various spaces, including an amphitheater for two hundred people. It also conceals staging that unfolds for occasional cultural activities such as lectures and film shows.

And the theatricality doesn't end there. The most is made of the double-height space, with merchandise dangling above in the "hanging city"—aluminum-mesh cages suspended from the ceiling on motorized tracks, allowing for continual repositioning, while shoes appear on the staircases as if abandoned on the way to a temple.

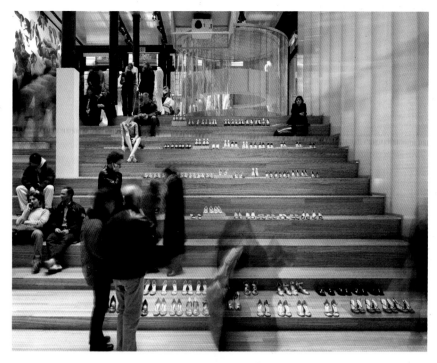

(Previous page) The exterior of Prada New York. (Opposite) Oversized mannequins mimic the clothed forms. (Top) Shoes are displayed as though just removed by people visiting a temple, and (above) looking into the store from the street. (Following pages) Two views of "the wave" which can transform into a theater space.

of simple trial and error, which has led to a casebook being created of what works and what doesn't. Back this up with footfall and sales figures and you have another approach to visual merchandising: Arcadia's Miss Selfridge fashion chain is based in the UK and has eighty outlets outside Britain, including Singapore, Saudi Arabia and Iceland. It deals in hundreds of thousands of garments and, "the most important thing is that it's very commercial," says creative manager, Matt Moss. "We only work with bestsellers and brand new pieces, nothing else, and we change it all every two weeks.

"We work to three thresholds. The first is the window, where you have to have that 'wow' factor, the second is just inside the doors and then you have the back wall which is very important to help draw people all the way through the store." As well as varying levels of displays, important looks and accessories are also displayed around the store in key places so that when a customer has gone to one, they look up and are drawn to another—the "pinball effect" of pushing people around a store.

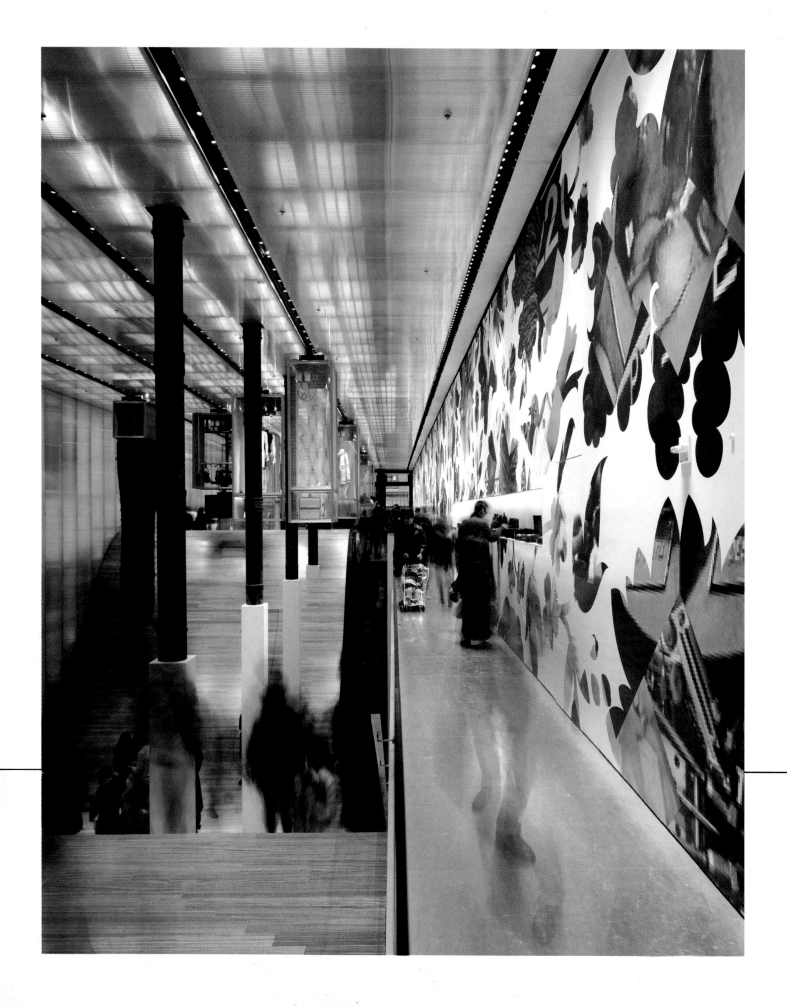

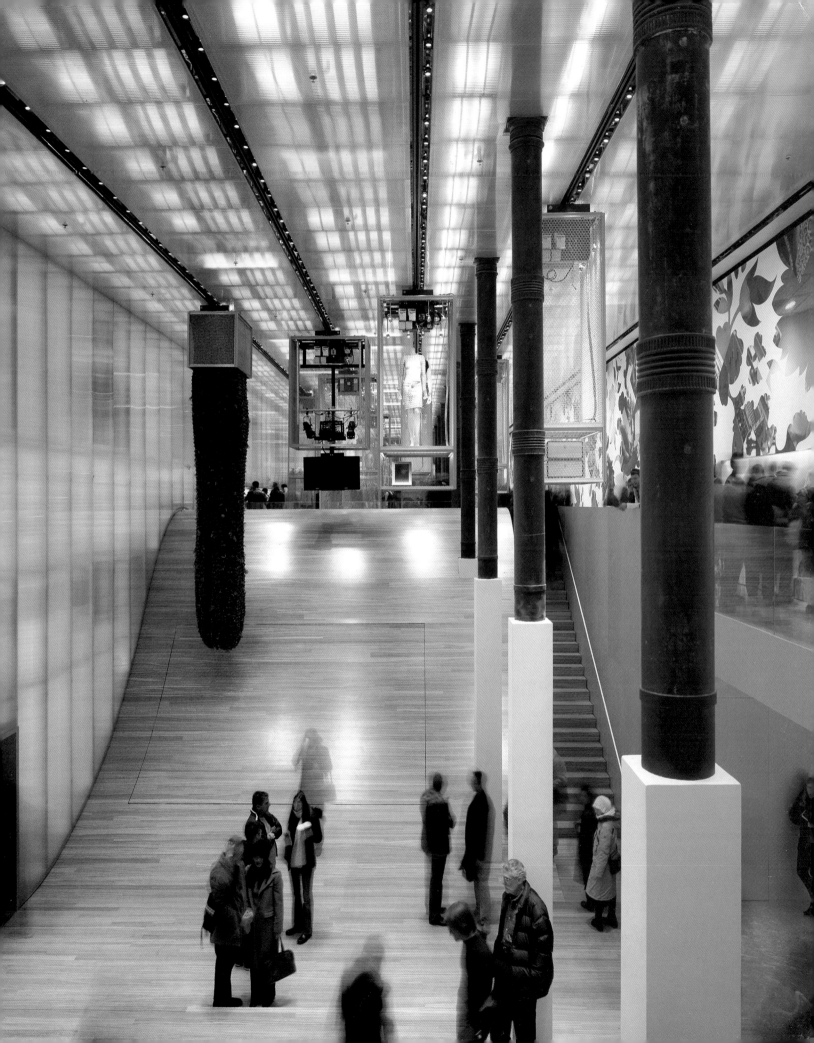

nakEd bunch, Tokyo

Japanese graphic designer and fashion illustrator Ed Tsuwaki is famous for his 2D female characters which leap off the page with their vibrancy, but admits he's always dreamt of giving them more life and making them 3D.

So when mannequin manufacturer Proportion London contacted him to see if he wanted to work with it on a collection, he naturally went for it and describes the year-long creative process as "very rewarding."

Tsuwaki worked closely with Christine Brickman, Proportion's creative director, to turn his drawings into reality. The final swan-necked creations are certainly attention-grabbing, and feature heavily in the fashion shop which Tsuwaki has opened to sell his own designs. Tsuwaki has toyed with the sense of proportion and the mannequins have massively elongated necks, which mean their heads virtually touch the ceiling.

"I opened my first shop in 2002, which was almost a year after I began working on my brand, nakEd bunch. The shop is in Daikanyama in Tokyo, which is one of the most fashionable areas of Japan, along with Harajuku and Aoyama.

"Although the shop is not particularly large at 33 sq m, it's been designed by Nobuo Araki, who I think is one of the greatest architects, probably *the* best, in Japan today.

"He has created something that is extremely minimal, but at the same time has feeling to it, which I was keen to have and which is a really cool combination. I never trained as a fashion designer, but as a fashion illustrator—and fashion victim—I've been dealing with it all my life!

"I think my personal approach to fashion designing is solid and very individual. What's more, the mannequins made in collaboration with Proportion London have become symbolic of the shop, and I'm really pleased that I can show my own clothes on my own mannequins—it brings the nakEd bunch alive!"

As well as the mannequins for the shop, a commercial collection was created, with shorter necks and billed as "boutique, inspired by Ed Tsuwaki." Five female mannequins have been created, all with different styles and attitudes, as well as a head on its own for accessories or just as an object in its own right (page 140).

(Left) The original drawing by Ed Tsuwaki, which was used by Proportion London to sculpt the mannequin. (Below) The store in Tokyo's fashionable Daikanyama district.

Science and accumulated business acumen have their role to play, but the presence of "creative" job titles in the process hints at a more artistic bent (albeit with a commercial nose) to the operation.

Bringing art to the fore, visual merchandising and display people will tell you that you have to create a story for the product and displays. There needs to be a sense of theater, and that's one thing retail in fact has been embracing with gusto for more than a decade. And with theater comes more art.

Former boss of homeware retailer Habitat, and now the man behind the massive renaissance of Selfridges (no relation to Miss Selfridge) department store in London, Vittorio Radice is desperate to drop departmentalization and create an altogether more theatrical in-store experience.

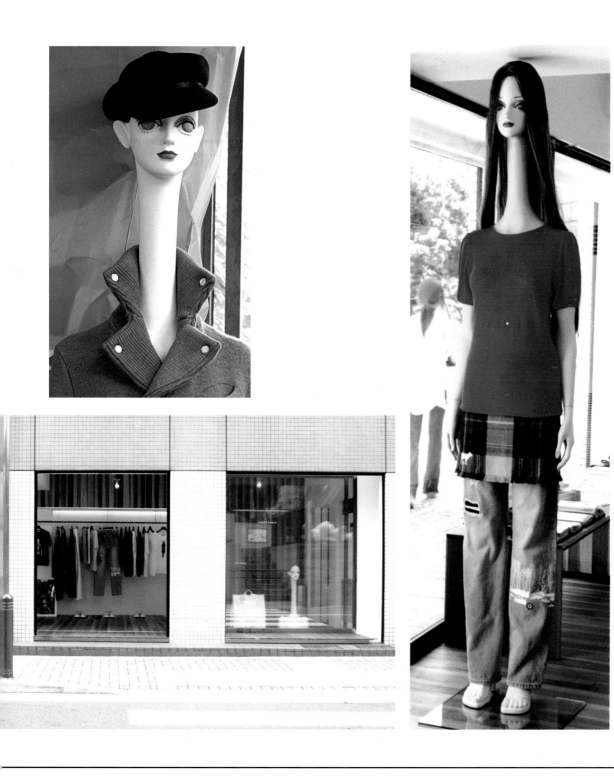

(Left) The long-necked mannequins produced for nakEd bunch. (Below) The store's launch graphics.

nakEd bunch

"In some areas there is going to be revolution… if you stay static for too long, forget it. It's important that we recognize shopping as entertainment. People want to try new things. We have to create a third place that people want to be in. You have your home and your work and then you have a third place—the pub, the gym, the stadium—we have to be that third place. You go because you want to be in this fantastic place, and the fact you come out with a shopping bag is just automatic. You want to take a piece of this place home with you."

So as to whether this is a science or an art, it has to be seen as both. The most important thing to remember is that it's a highly commercial business. Acquired knowledge and methodology based upon that has a major role to play and so, increasingly, does the science of retailing.

(Left) The highly graphic products and the store at night (opposite). (Below) Kinkinki, the promotion character.

Tokyo Life, Selfridges, London

In a major attempt to create a sense of drama and theater in-store, Selfridges, the accepted leader of the UK department store renaissance, created a month-long, themed promotion. Japanese retailing, a particular penchant of chief executive Vittorio Radice, was the basis and "Tokyo Life" saw a massive influx of Japanese merchandise, arresting graphics and bright pink in-store vending machines.

Most extraordinarily, the corner windows on Oxford Street were ripped out and a 24-hour, fully functioning, Japanese convenience store was installed for the

month of the promotion. The planning authority permitted Selfridges to take out their historic listed windows for the first time in its history, but only allowed a partial extension of opening hours.

"When we came up with the idea, everybody was really shocked and said we'd never get it through planning," says Selfridges design manager/creative director Mat Wilkinson. "The idea of taking a window that the public has never had access to and turning it into a shop was really exciting."

Working closely with the store visual merchandising team he created a fully merchandised store run as a franchise. "We approached it as a normal Selfridges shopfit," says Wilkinson. "But the more it developed, the more we realized that to get a really Japanese feel to it, and to make sure we had enough stock in there, we really had to adjust the fixturing to bulk it out and make the most of the Japanese products.

"It was a fantastic project because it actually became commercially viable as well as being a great public relations vehicle for us, and visually it was very strong."

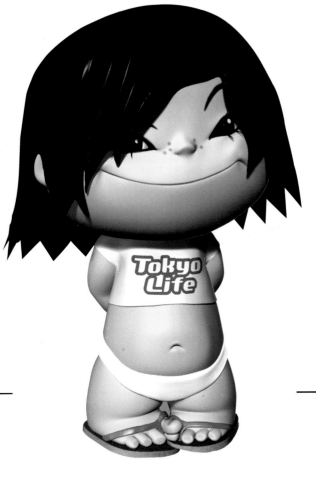

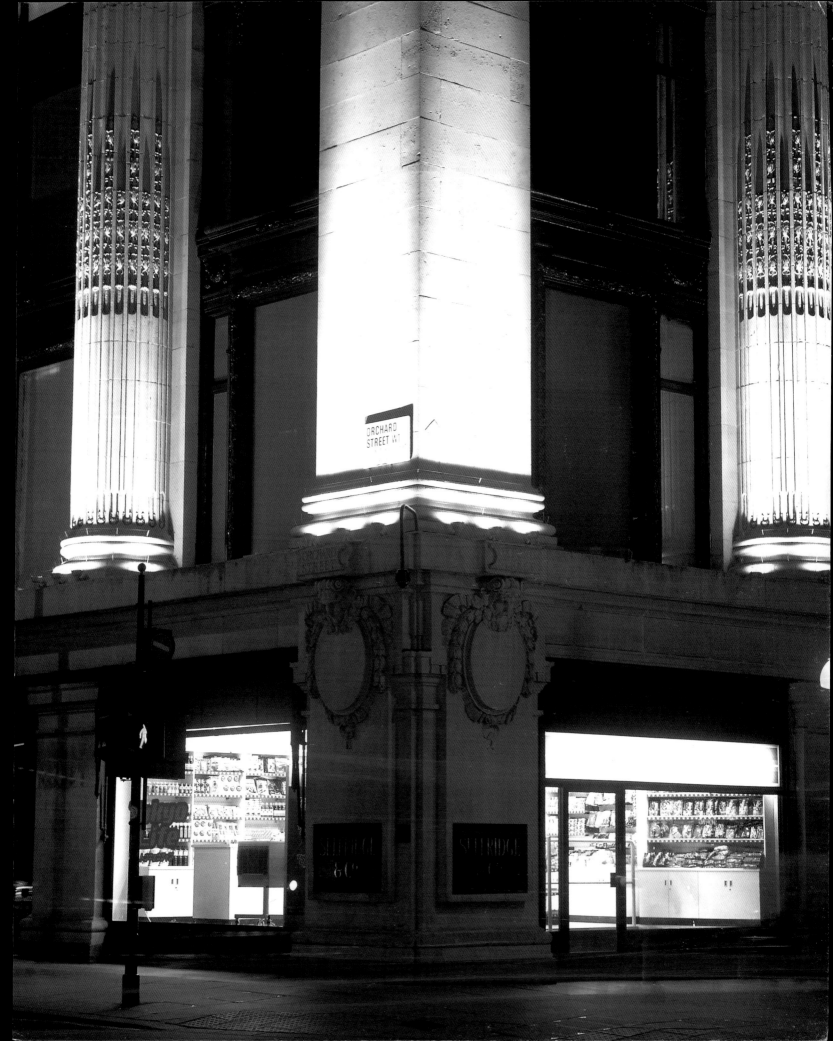

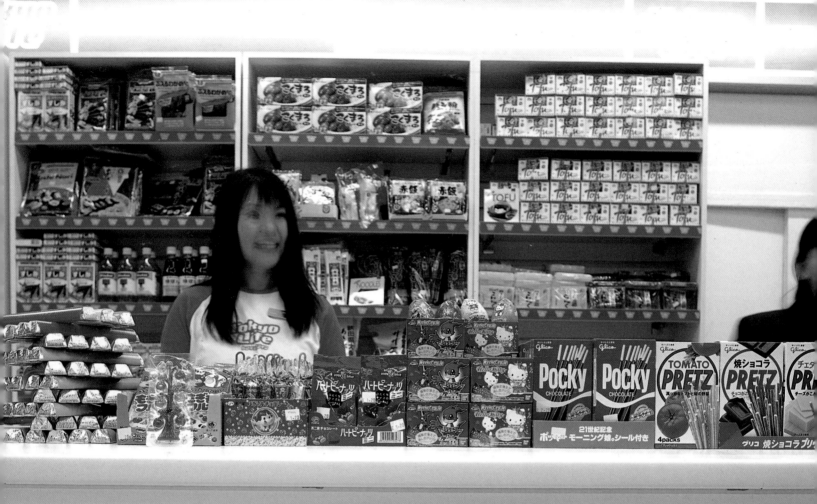

Bronze finish shopfronts.

Bonsai graphics to glazing.

Red painted walls.

INTERNAL ELEVATION A

Corner shelving unit
with pegged top section.

Counter unit.

Back wall unit.

Virtual to reality—the convenience
store as imagined (right) and how
it turned out (opposite).

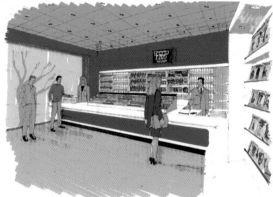

Back wall unit with shelved upper section,
lockable base cupboards. All white gloss finish.

Sign logo to back wall.

Red painted walls.

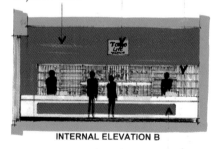

INTERNAL ELEVATION B

Counter unit with illuminated opaque
panel to front face.

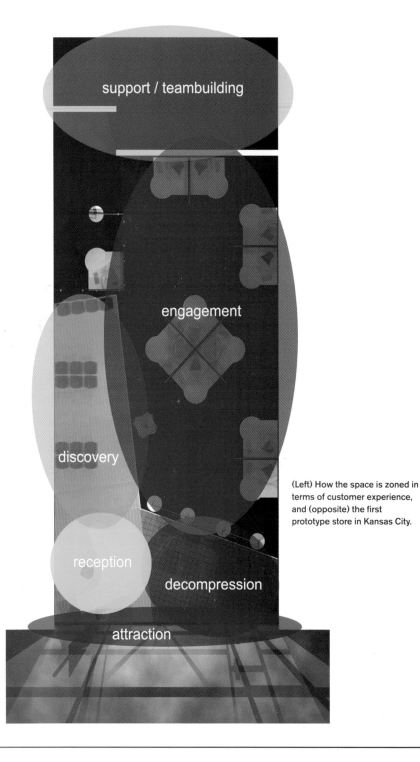

support / teambuilding

engagement

discovery

reception

decompression

attraction

(Left) How the space is zoned in terms of customer experience, and **(opposite)** the first prototype store in Kansas City.

H&R Block, Kansas City

When a retailer has more than ten thousand separate retail locations, it has to apply a scientific approach to retailing. H&R Block is a US service retailer, selling tax, mortgage and financial services.

Psychology and research inform every part of the design work carried out by consultancy Miller Zell, which trumpets Integrated Store Development and the simple formula $V = R/C$, that's Value = Results divided by Costs.

Miller Zell's Ian Rattray claims: "This design differentiates itself from others in this marketplace through the use of a specifically developed, choreographed customer experience, driven by the lessons learned from proprietary consumer research. The design is divided into five zones, each performing a specific function: Attraction—a powerful beacon that projects the office presence to the street; Decompression—clients entering the office psychologically 'decompress'. This zone educates the consumer in 'it's not just taxes anymore'; Reception—clients are introduced to the full range of services and products offered by H&R Block; Discovery—clients self-educate in financial planning and are prompted to request further information; and Engagement—this is where the relationship is built."

"The design reflects the new face of H&R Block as the provider of financial services to middle America (ie servicing Main Street, not Wall Street). The custom nature of the components—nothing is 'off-the-shelf'—the simple interaction of pure, light forms, helps to create a very flexible and unique 'retail form language' for H&R Block. And because the solution had to work in ten thousand differently configured locations, it had to hit a budget in the low teens [dollars] per sq ft.

"We had a very short timeframe from initial project inception to completion of six hundred test offices in eight months, including research, analysis, strategic development, concept and design development, engineering, prototyping, manufacturing in China, Korea, the US, and Mexico and finally, installation. It has been a marketing strategy to get the brand into the marketplace as much and as fast as possible, hence the budget and timeline constraints.

"The 'scrim wall' in 'Decompression' is worthy of mention since it has been distilled down to its most elemental parts, expressing a purity of function and elegance that reflects the new H&R Block brand. The graphic support rail allows the fixture to be used as a very efficient marketing tool, and the messaging can be changed at will with very few cost alterations."

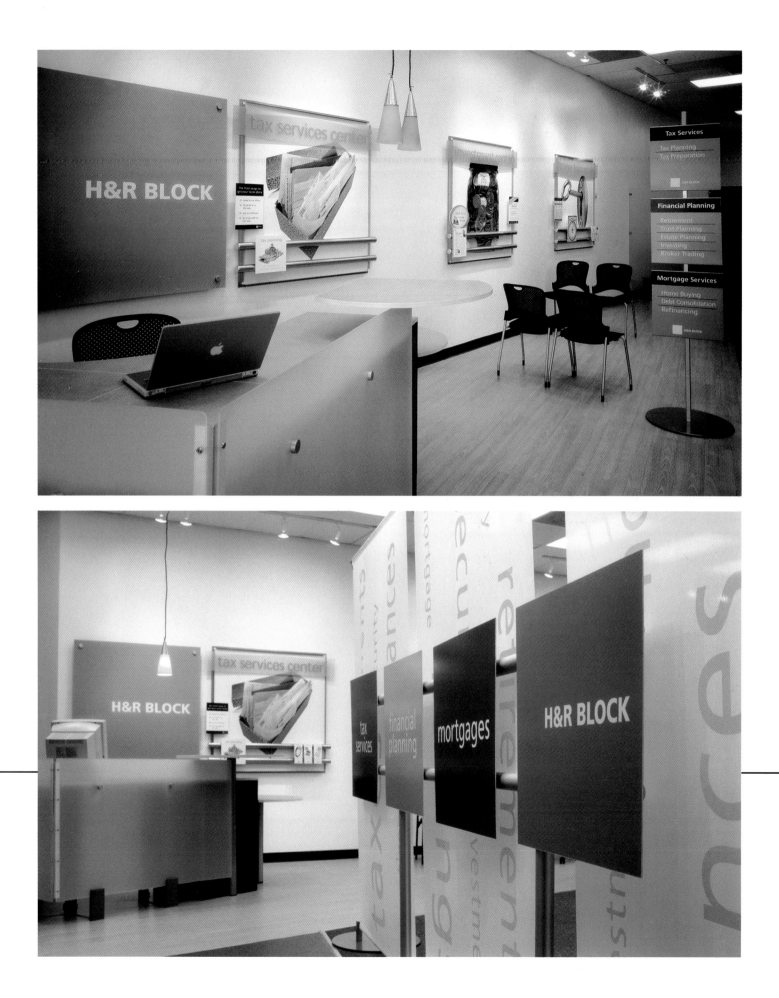

(Above) Cameras were used by ID Magasin to study how shoppers shopped for Instants.

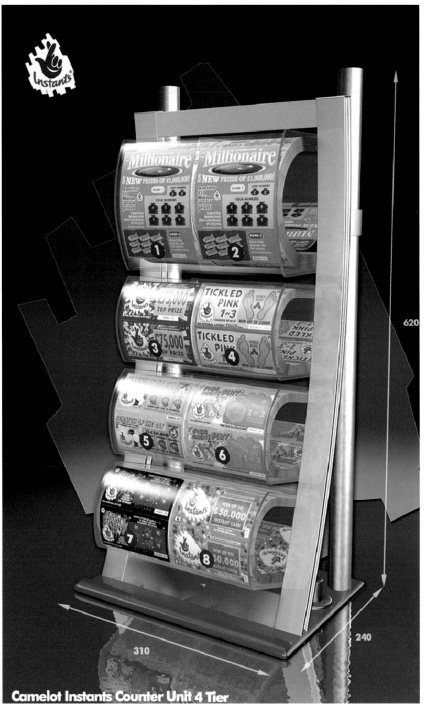

Camelot Instants Counter Unit 4 Tier

Instants, UK

Instants, the instant pay-out lottery scratch cards run by Lotto in the UK is, perhaps surprisingly, the third largest brand in the UK, worth como £580 million a year. It is just below second-placed Coca-Cola (£640 million).

Research and design specialist ID Magasin, which works across all retail sectors, was drafted in by Lotto to make sure the brand was making the most of itself, its selling positions and ease of use.

"We employed people who did and didn't play to see how they shopped," says ID Magasin founder Siemon Scamell-Katz. "We used a mixture of filming people and the Eyemark recorder [which records where people look] to look at eye movement and subconscious decision-making in host retail environments.

"The top left of the display proved to be a visual hot spot. That's where most of the people looked for a number of reasons: ergonomics—it's at eye level, and there tended to be a point-of-sale header above it that directed eye movement on to the left-hand side of the unit.

"What we tried to do was bring the hot spot down within the unit so people aren't simply looking at the top of it. Also, with Instants they tend to sit in front of tobacco displays where you have an awful lot of visual noise, so another thing we tried to do was frame the Instants to create a distinct visual area that would also have the effect of lowering the hot spot."

Outlet testing in multiple chain stores, grocery and confectionery, tobacco and news stores (CTNS) got some hefty sales results—fifteen percent increases. Following some minor tweaking from operational feedback, particularly concerning security, the units were rolled out to 7,000 stores.

Scamell-Katz describes the resultant unit: "An aluminum frame carries a device that is flexible, so the high-impact, edge-lit acrylic cassettes which hold the Instants cards can be differently arranged. It should have the flexibility to survive throughout the lottery license period, which is about eight years now."

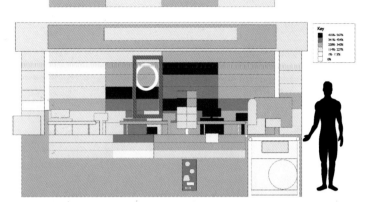

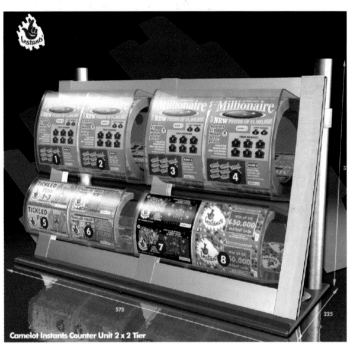

Camelot Instants Counter Unit 2 x 2 Tier

(Top) Eye movements where mapped, showing which areas were looked at most often. (Above and opposite) Research results were used to create these two new display units.

Brand experience or volume sales

The brand is still king. There have been slight brand backlashes in recent years, but they have been rather minor ripples on a very deep sea. And the brands are continuing to deluge us with their values, which it seems we are quite happy to soak up or let them just wash over us. In retailing, brands have created very individual beasts, some might even call them white elephants.

There are flagships and then there are flagships. For most chains their flagship is their largest store in the prime retail location. But the big brands, in particular the fashion labels, do it differently. For them, these flagship stores are about creating a 3D embodiment of all that their brand is about. Brand values made solid.

Over the last decade, stores have sprung up which major on style and in which the product is often thin on the ground. In these stores it's more likely to be on the walls, gallery style, as the product is elevated to art status.

Levi's, Global

Jeans manufacturer Levi's once dominated denim with its award-winning ad campaigns, but the market soon became saturated by designer label own versions and sales of the material in general were on the slide, as the vogue for new and more hi-tech fabrics took hold. Once everybody had a pair of jeans, now everyone has a pair of cargo or snow pants.

However, with the help of their new products, new ad campaigns and, significantly, new stores, Levi's has brought itself right back to the pinnacle of fashion. More importantly, the coffers are filling up nicely again.

Key to Levi's renaissance was a targeted marketing campaign aimed at four clearly defined consumer profiles. Each of these profiles carried with it its own kind of store, most of which have been designed by design consultancy Checkland Kindleysides.

The first two were very much about the brand experience and aimed at the early adopters and trendsetters who would be setting the fashion agenda for others to follow, whereas the other two were aimed at "regular and sensible" users.

(Above and below) Levi's London flagship inside and out, and the San Francisco store (opposite). (Previous page) A customization station at the Berlin flagship.

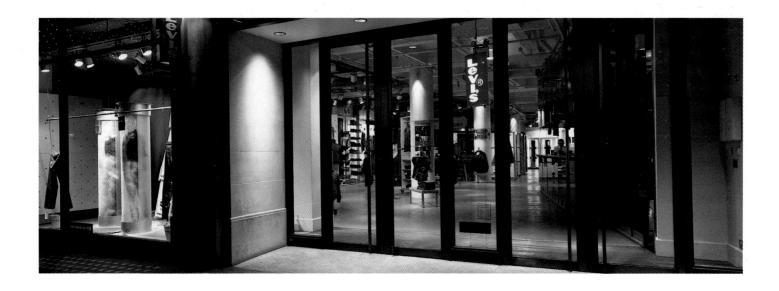

These places are about selling a lifestyle and about giving customers something to aspire to. There is product and there are sales, but these are often secondary concerns. Frequently, these stores are the pinnacles of a niche marketing approach. The volume sales occur at smaller shops in lesser locations or concessions.

Nike Towns are prime examples of this. Their biggest stores in New York and London have "decompression" zones, which take in most of the ground floor! The London store on Oxford Street is on what is probably the most expensive retail site in the UK if not Europe, yet Nike closed it down for eighteen months while Nike Town was created. Nike never talk about the cost, although estimates put it at around £500 per sq ft for a site of around 70,000 sq ft. But what the store does now is reinforce the brand message to more than two million people who pass through its doors every year.

"Flagship stores are a good idea in theory, but few retailers really seem to understand what their function should be," says Matthew Brown from Echochamber, the Web-based retail market analyst. "They just think it means a large store with full range.

"True flagships like Nike Town are great, but are obviously loss leaders, which doesn't necessarily matter. However, I think that the best flagship I have ever seen is TOPSHOP in Oxford Circus. It makes plenty of money, is markedly different from the other stores and is a real destination in itself. This is what 'flagship' really should be."

Levi's is a familiar brand that has embraced the flagship idea with its stunning San Franciscan, home town, store and latterly with others around the world. It also has a whole series of other formats and is one retailer that seems to know exactly why it has a flagship as well as its other formats.

The Berlin Buttenheim icon store—individuality is the key for this sector of the market.

At the top of the pyramid, as Levi's see it, come the "cultural creatives and strutters," and for these people a completely new kind of shop was created, the Icon Store, or to be more precise, the Icon Stores. Here branding almost takes second place to individuality. Each of the stores has its own name—Buttenheim in Berlin, b-fly in Milan, [z]inc in Barcelona and Cinch in London—a unique design to fit in with the very carefully chosen cities they are sited in.

The aim is "the display of leading-edge denim products in a way which will appeal to the target group. The store design fit-and-feel is like a small independent retailer and the product is displayed in a clear and uncluttered way as in a gallery, to elevate the product to higher status. A unique range of accessories and other brands have been chosen to be sold alongside the Levi's product and each store chooses items relevant to its own market.

"The structure of the stores has been designed to allow layout to evolve, and the materials are honest and utilitarian—mild steel, distressed acrylic, clear PVC, black rubber and industrial paint finishes. Add to this 'found articles' such as lighting and seating to furnish the store." Even the staff are seen as an "integral part of the store" and are chosen for having equivalent brand values, such as being confident, youthful, sexy, individual, and creative.

The branding is not particularly overt in these stores and it's easy to think they are independents, raising the cachet of the branch with both the public and other retailers. Branding is however very much to the fore in the next layer of the pyramid—the flagships.

From San Francisco to London, these stores are branding powerplays; 3D renderings of the brand values aimed at fashion leaders.

Taking Checkland's London store as an example, it needed to be "a flexible space in which the different moods and expressions of the brand can be exhibited. The whole store should be multi-functional and capable of being transformed into a club or event venue. Every element in the store has been designed to ensure that the store can be redefined and reshaped to achieve this transformation from retail to venue. All floor fixtures are mobile, including fitting rooms and the wall-based merchandising which uses a door system, enabling products to be locked away." All this puts the brand at the cutting edge of fashion, reinforcing the cool trickle-down effect in the retail pyramid.

The next two sections of the pyramid are aimed at the general public. This is the volume market sector, the big sales. For Levi's that means, "Fifteen to nineteen-year-old regular guys and girls." These two sectors are

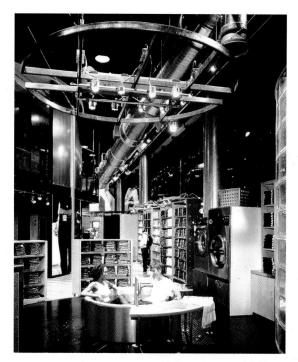

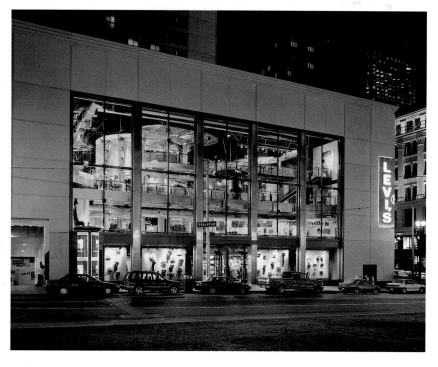

(Left) Two intrepid customers take a shrink-to-fit bath in the San Francisco flagship, the exterior of which can be seen below.

firstly the Original Levi Stores (OLS)—the high-street shops—and, at the bottom of the pyramid, holding it all up, the Shop-in-Shop concepts.

In the OLS, key parts of the flagship stores are retained but are nowhere near as extravagant, stock densities are much higher, and shopfitting and fixturing costs need to be considerably less to take into account the sheer volume needed. "The stores are designed as 'flexible' gallery spaces, where the products are the prime exhibit. All of the key brand messages and merchandising signatures are filtered down from the flagship stores."

In the Shop-in-Shops, one of the key factors was to create better control in multi-branded environments. In these volume sales areas Levi's commissioned display system manufacturer CIL International to create a new branded in-store merchandise concept, which would be "easy to install and inherently flexible."

CIL used its Cilplan system as the basis for perimeter and mid-floor gondolas, which use a satin chrome finish with blue acrylic center panels and a large red Levi's tab logo. These have gone into various department stores, multiple chains, and independent retailers.

Levi's retail presentation manager, Paul Craven, says,

(Below left) CIL's visualization for one display unit variation and the finished article in store (below right). (Bottom) Poles create a "wave" of jeans.

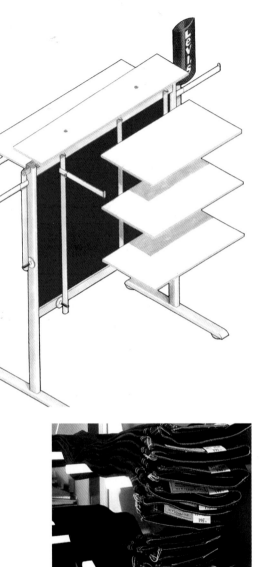

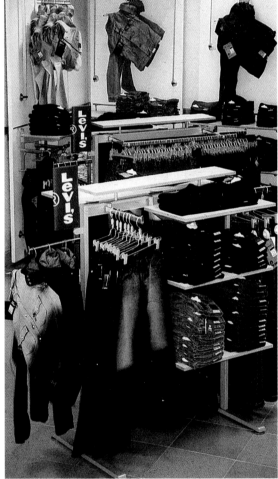

"We achieved a four-week payback on the cost of the fixturing as a result of the sales uplift."

In fact, at time of writing, sales in all the formats had soared according to independent research and footfalls were up massively as well. While Checkland admits that new products, such as the Engineered Jeans and subsequent ad campaigns had a role to play in increased sales, it points out that there is "a chasm" between sales from new stores and those with the old design. Levi's has continued to work with Checkland on both Pan European and US roll-outs.

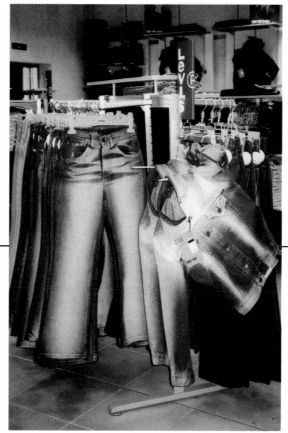

(Above and above left) 2D displays: chalk graphics in the London icon store Cinch, and a visual for a display wall, both by Checkland Kindleysides. (Left and far left) Details of the CIL-designed concession display units.

Bespoke or off-the-shelf

While there's an undeniable "me-too" element to fashionable change in retail environments, differentiation is still the dominant factor. Stores want you to know you're in their shop and not in that of a rival. The environment is an extension of the brand itself.

One constant is that shops sell products and if they sell products, then they are going to have to display them in some way, whether it's as highly treasured individual items with plenty of space or whether it's fully racked out, in all styles, colors and sizes.

The display units and systems, the fixtures and fittings, play a huge role in this differentiation and brand enhancement. As you'd expect, there are almost as many solutions to display as there are retailers. It's only "almost" though, because many will use merchandising systems created by specialist manufacturers. This is particularly true of independents and smaller chains, which are limited by cost.

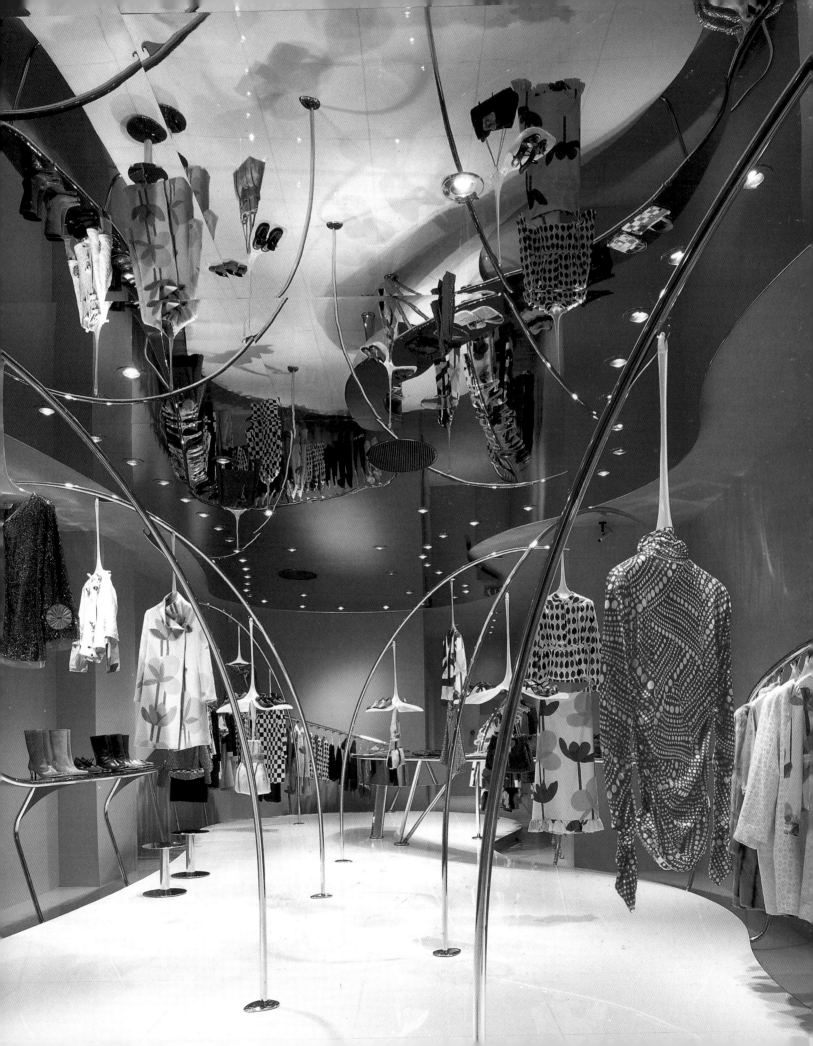

(Opposite) Future Systems'
drawings clearly show that the
display system was integral to
the overall design for the
London store. (Previous page,
right, and below) Marni, London,
in all its reflective glory.

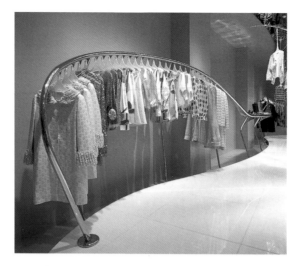

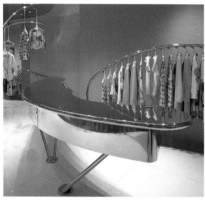

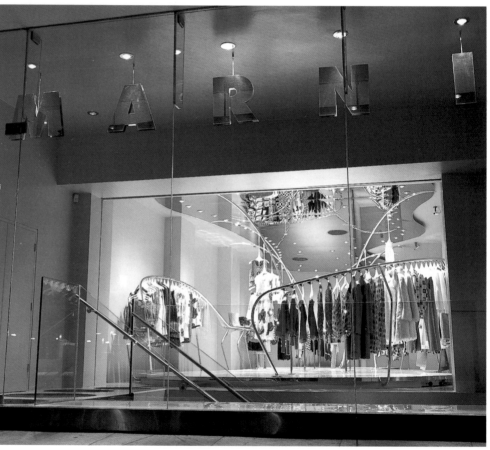

Larger chains, particularly in fashion and homeware, often use off-the-shelf displays, but many of them will want theirs individualized. The creation of "specials" forms a large part of the work of merchandising manufacturers. The degree of customization can vary from a different finish to completely redesigning profiles, and creating new units for specific purposes and positions. In fact, pushed to the extremes of customization, the end product often bears little resemblance to the off-the-shelf version—which is exactly the effect wanted by the retailer.

According to Alu, the merchandising system manufacturer, "Retailers want to be unique. The brands will come and say, 'This is our product and this is what we are hoping to do.' We'll design extra pieces to give them their own identity." This obviously carries cost implications with it, as does any kind of alteration to the basic units, but that is often not an overriding factor when the brand is at stake.

"Brands continue to grow in importance. What we are talking about here is packaging around the product. The emphasis on brand has been translated into an emphasis on brand fixturing," says Philip Morris, managing director of UK merchandise system manufacturer CIL.

Marni, London

The clothes and the way they are displayed were absolutely critical to the retail interior concept created for high-fashion brand Marni, by leftfield architecture firm Future Systems. When the architect was brought in to create a concept for all the Marni concerns—stand-alone shops and units within department stores—inspiration came from the fashion collections.

"The spirit of the shops has been generated by the clothes themselves—textures, color, composition, and beauty in nature are the inspirations for this response. We attempted to create an interior landscape. The clothes became a part of an overall composition, not separated from the design of the space but part of it," says Future Systems.

"The concept was to present the clothes on a sculptural white island, which sits against the brightly colored backdrop of the rest of the shop. In the stand-alone shops, the curved shape of the island is literally reflected by a mirror-polished stainless-steel ceiling in the same shape, removing the feeling of being in a typical rectilinear shop. The background color can be chosen to suit a particular collection and can be varied with changing seasons to give a fresh look from time to time.

"Selected clothes and accessories are displayed on tall, delicate stainless-steel branches or, in shops where height is limited, from stainless-steel ceiling hooks. Clothes are also displayed from a stainless-steel rail, which curves around the perimeter of the island; the dynamic element that changes from hanging rail to flat surface for display and serving counter. The clothes are hung on specially made, plexiglass hangers designed to be sculptural elements within the overall shop design. Unlike the traditional treatment, these hang below the rail in order that the rail reads as a continuous, sinuous line.

"The intention is to create an environment that is abstract. The clothes appear to float in a simple and fluid way, yet are accessible and tangible to the public."

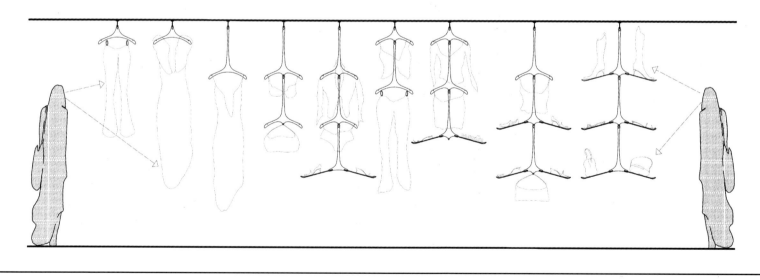

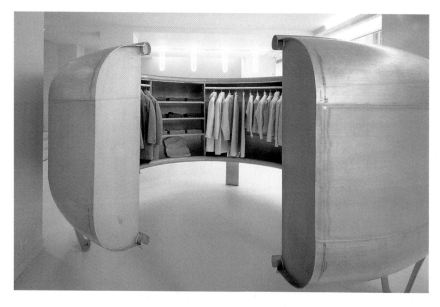

Mandarina Duck, Paris

When Mandarina Duck, the accessories and latterly clothing label, brought in the Dutch group Droog Design to design its Paris store, it knew it was going to get something slightly different from the norm.

Droog is a loose association of designers which likes to defy definition. Its surprising designs include soft rubber vases, a cabinet made from old drawer units tied together, a camouflage shirt with a camouflage tie for Levi's, and seating which when viewed from above displays emotive icons like the cross and the swastika.

Founder Renny Ramakers admits Droog is rather difficult to categorize, saying, "We are collectors and art directors. We gather together a wide range of products and initiate projects with various designers. Our objective isn't commercial, but cultural." It's exactly this leftfield, anti-commercialism that makes them so interesting and commercially viable.

Droog worked with Dutch architecture firm NL Architects on the Paris store, and true to form, produced something like nothing ever seen before, complete with elastic-band display systems (since recycled as letter racks for the wall), and free-standing cocoon display units which conceal the products within. Each cocoon is different and seen as a self-contained installation, using different materials such as resin and rubber. The clothes are also concealed, inside a giant floating steel doughnut, with one small entrance, which again almost completely encloses the product, making the customer work quite hard if they want to buy anything. This does, however, mean the overall impression is a minimal and uncluttered environment. If customers actually find something they fancy and want to try it on they can head for "the cornfield"—the changing rooms which are a sea of swaying corn-like glass fiber.

The store also features a revolving spiral staircase which draws people up through the store, pin-cushion displays that look like giant executive toys showing imprints of suitcases and bags, and even wafer-thin vacuum-packed clothes displayed on the walls as if they've been thrown there. It's retail, but not as we know it.

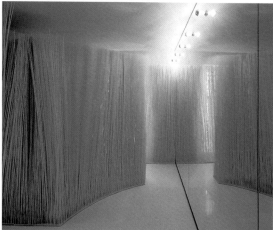

(Top) A doughnut-shaped cocoon display unit enclosing the product. (Above) The "cornfield" changing rooms made from glass fiber. (Opposite) A bed of pins gives customers an impression of the products.

Alterations to merchandising systems will be designed and carried out by the manufacturers or in conjunction with designers and architects working on retail schemes. Often, however, the retail architect or designer will want to go the whole hog themselves and create totally bespoke display solutions. There is no higher expression of brand individuality than a unique display system.

Mandarina Duck and Marni are two stores featured in this chapter where the designers took on the display mantle and allowed their imaginations to run riot. Both Droog and Future Systems, who worked on these two projects respectively, created unique brand-enhancing design solutions. There are other examples elsewhere in the book, such as Prada (pages 14–17), Mulberry (pages 84–7), and Lacroix (pages 88–9).

It's all a question of degree and often that degree is pretty much a question of cost, although off-the-shelf can be just as stunning as bespoke.

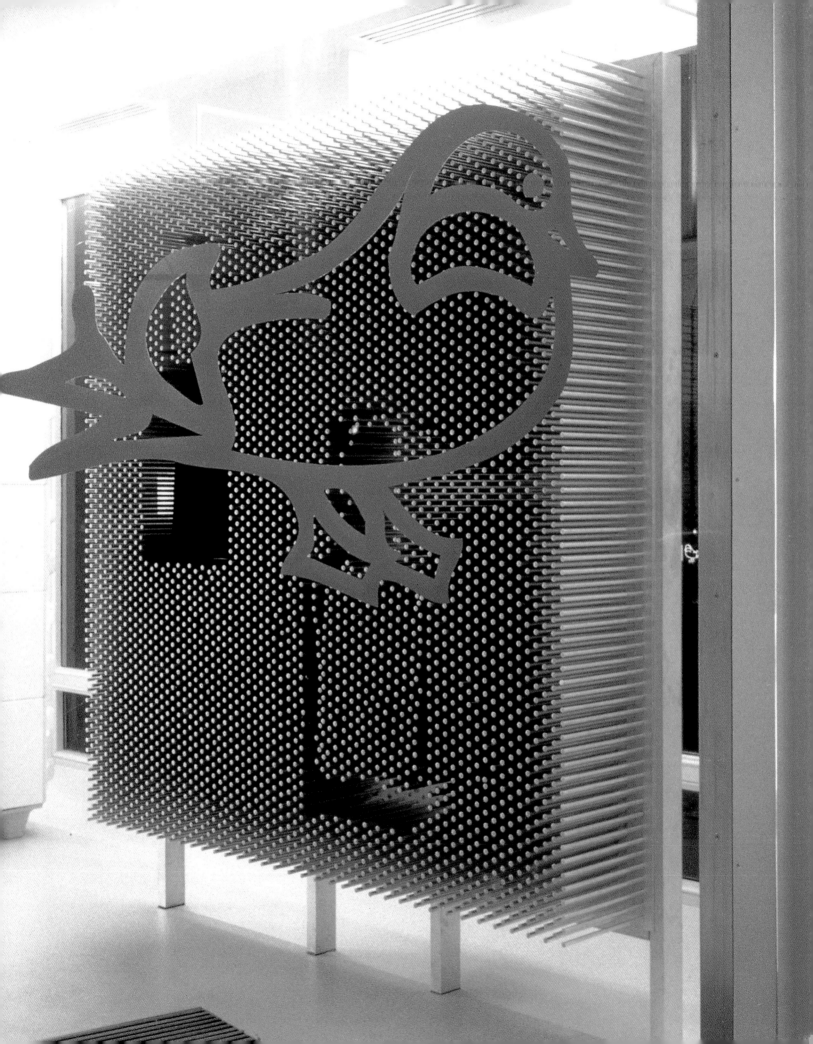

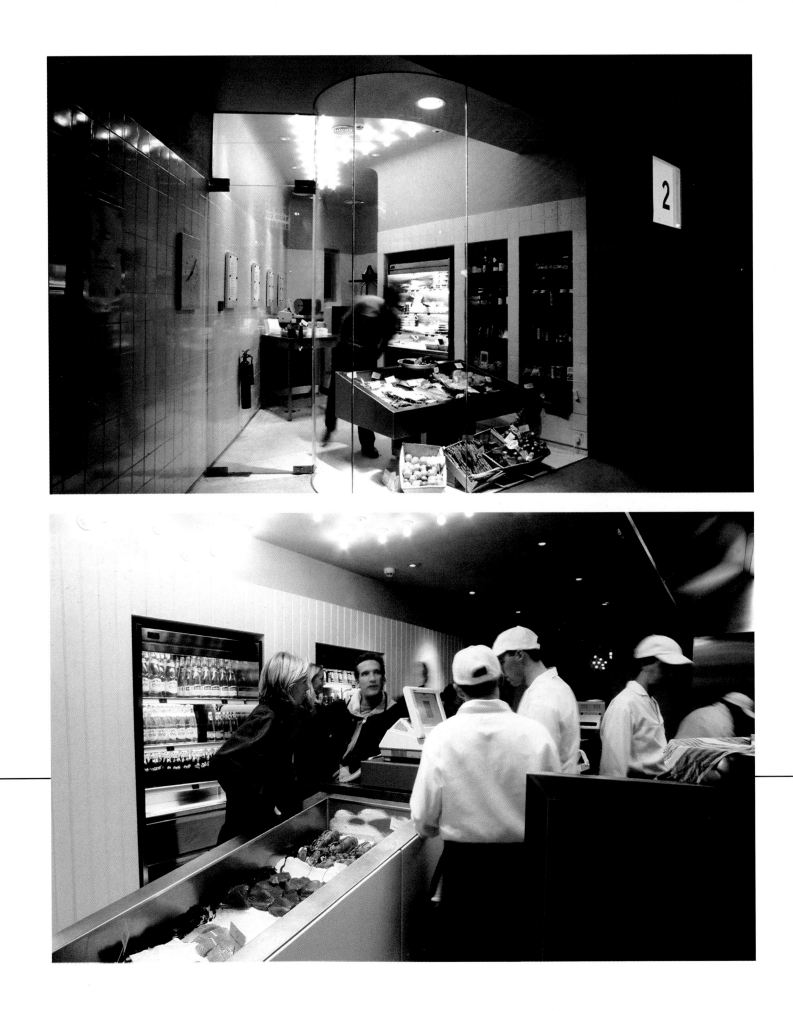

Fishshop, London

There are few kinds of display which are more timeless and, in fact, more appealing than fresh produce in a market setting. Stacked high, relying on repetition and intensity, it naturally draws the eye and the attention, as well as stimulating the taste buds.

When architect Gundry & Ducker got involved in the design of the quintessentially English fish and chip shop, it wanted to go back to basics and draw on the market roots to bring the idea of quality and freshness to the fore. Unusually, the chip shop also included a selection of fresh, uncooked wet fish for sale. A separate wet fish shop was also created a few doors down.

Fishshop and Fishbar meld the classic and the minimalist in a unique new concept which has been designed to be rolled out as a chain.

"Materials used include deckchair-striped awnings, white enamel and white terrazzo floors, with duck-egg blue paintwork, as well as an oversized map of Britain," explains architect Christian Ducker.

"The Fishshop design is contemporary, but makes reference to the forms and colors of the traditional fishmongers, the seaside, and mobile seafood stalls.

"The concept for Fishbar is a 21st-century interpretation of a traditional fish and chip shop. The design intends to create a message of quality and freshness and to reinvent an English identity for takeaway food."

Gundry & Ducker has controlled the whole environment and in particular the display aspect of the shops, since the product is so central to the schemes. The fronts of the stores are dominated by the steel, fishmonger-style fish display units, which are underlit with blue neon at night to add emphasis, while the choice of color also promotes the ideas of freshness, cleanliness and hygiene.

Both shops make a feature of large internally lit refrigerators—again freshness is brought to the fore. Glass is the other key element for the shelving and the frontages, which are kept as open, airy and light as possible, even to the clean sans serif typeface.

Ducker adds: "The two shops are intended to express their separate functions but to convey their identity as a complementary pair."

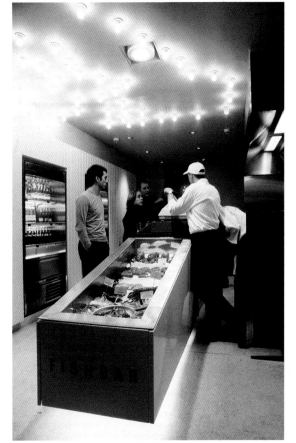

The Fishshop (opposite top) with its deckchair awning (below), evoking seaside imagery. The unusual Fishbar (opposite bottom and left) which serves cooked fish, also has a wet fish display.

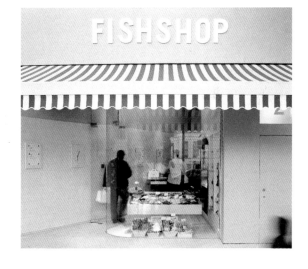

Magma, UK

Finding a better way to display books has been a key element of [in]side out Systems (IOS)'s work with art and graphics bookseller Magma. The titles Magma tends to stock will all have carefully considered cover design. The main aim was to find a way to present the books facing forward, to let them sell themselves.

After the success of the initial Magma store in Covent Garden, London, two more sites were identified, both in fashionable, creative areas—the first in Clerkenwell, London and the second in Oldham Street, Manchester.

"Challenged by this opportunity to reassess the original concept, our team worked on a built-in shelving structure spanning between basement and ground floor," says IOS founder Julie Blum about the Clerkenwell project.

"Penetrating the floors' perimeter, this internal structure creates a series of light wells along the internal shell, whilst stretching a glowing translucent membrane within the space. Gradually, the shelving system transforms the shop into a gallery and interactive work space."

On the Manchester branch: "Seduced by the Northern Quarter's creative impulse, Magma asked IOS to respond to Manchester's city tempo. To emphasize Magma's organic growth, our design organizes a series of curved planes wrapping around the space from horizontal to vertical. A 'bar' waving along the wall faces an uplifting metal structure illuminated from behind.

"Our curved planes are an invitation to lean while surfing images. Visual yet physical, those fluid shapes are hoped to provide a pleasurable sense of vertigo." The shelving work and experimentation has been a success, and has spawned a new shelving system called Montse, in production and now widely available to other retailers as a system in its own right.

Its key factor is that it can be adjusted up and down to accommodate the wildly differing sizes of books, without any part of it having to be removed. It is just adjusted with a pull-push action and the system is also "completely independent from the wall and floor," giving it a floating effect.

(Opposite top) Plan of the book display wall units and curved shelving, meant as an interpretation of the organic growth and tempo of the host city—Manchester. (Opposite bottom) How Manchester finally looked. (Below) In Clerkenwell, built-in shelving stretches between two floors.

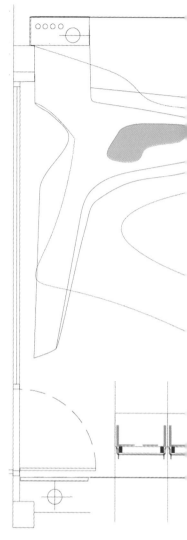

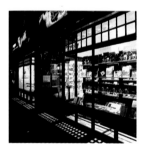
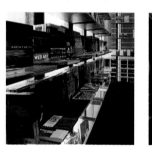
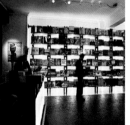
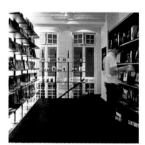
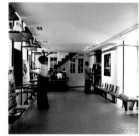

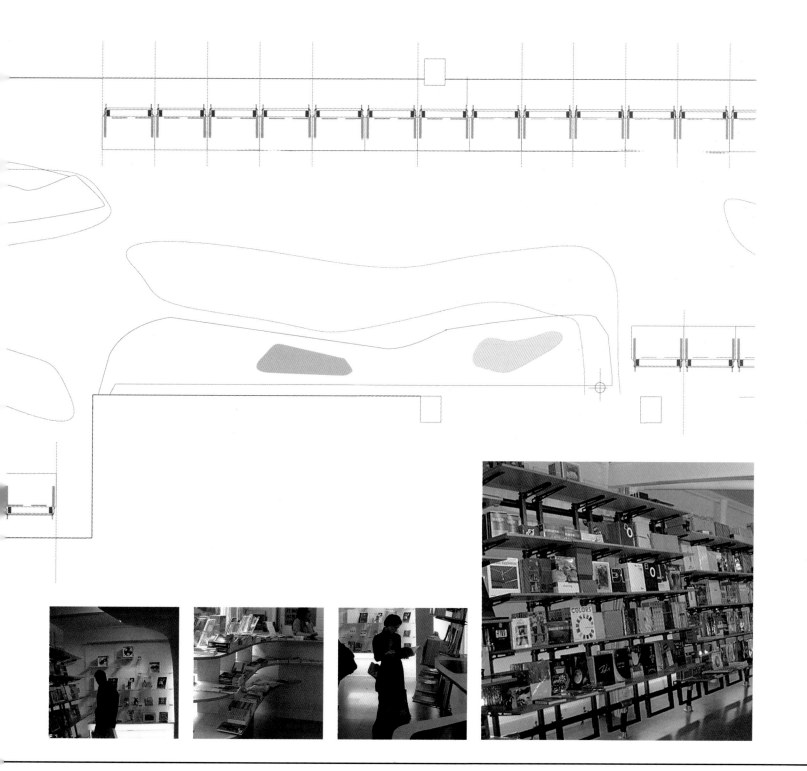

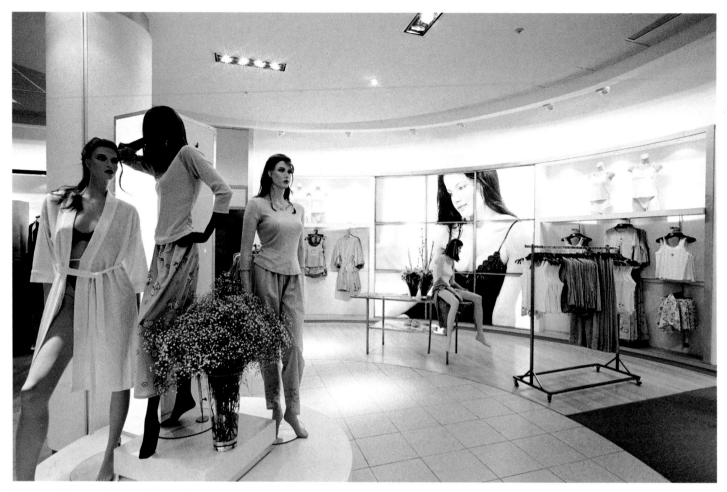

Woolworths, Durban

The famous retail entrepreneur F. W. Woolworth would be surprised to see what has become of his cheap goods emporia if he looked to South Africa. This Woolworths, in the Gateway Shopping Center, near Durban, is an award-winning department store.

Stocking own-brand clothing, cosmetics, homeware and food, the store beat off competition from Sears, among others, to win top honors in the Visual Merchandising and Store Design magazine's department store category.

The design of the store was carried out in-house and features uncluttered floor space. The stylish displays provide a clean canvas to offset the colors and shapes of the merchandise in the 54,000 sq ft store.

"Most of the visuals are backlit to provide a glow and the lighting levels are brought down to achieve the calm, intimate effect that the designers wanted," according to Errol Solomon, head of visual display, who was closely involved with the design work.

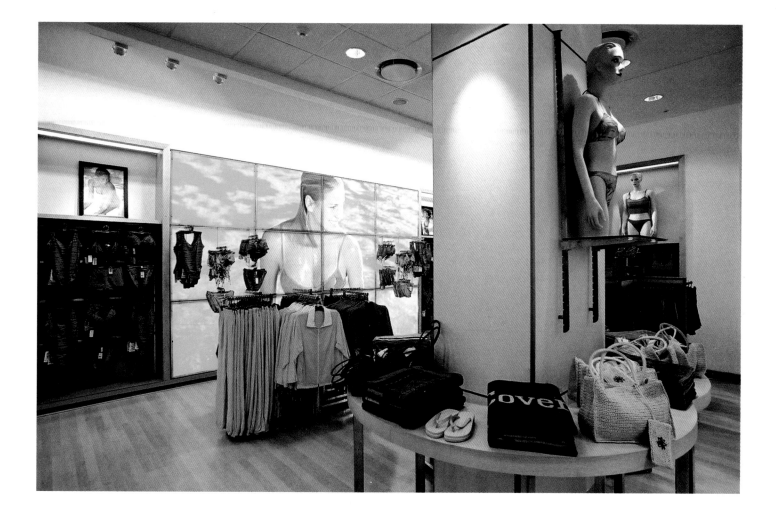

The scheme relies heavily on merchandising systems manufacturer CIL's Cilplan system. Cilplan 10 was used in the illuminated curved graphic walls which are a key feature of the scheme. The graphic panels attract the customers' attention, who then find the panels are framed by merchandise.

These products are partially lit by the graphic itself as well as by accent lighting.

Cilplan was used for all the swimwear, womenswear, menswear, childrenswear, and lingerie departments, as well as the homeware section of the store.

(Opposite and above) The award-winning, uncluttered new look for Woolworths in Durban, South Africa, brings the walls to life with large backlit graphics incorporating display units.

Harvey Nichols, UK

Harvey Nichols has an individual, highly sophisticated style all of its own, one that design consultancy Four IV has helped to nurture and grow, in a relationship spanning almost a decade.

Four IV was already involved when the single site department store in Knightsbridge, London decided it was time to branch out, and it's been at the design helm for the opening of the store's two projects in Birmingham and Edinburgh.

For Birmingham, "the brief was to develop a concept for Harvey Nichols' 'small' stores or a 'boutique concept,'" says consultancy managing director, Chris Dewar-Dixon. "The stores (on average 15–20,000 sq ft trading) contain 'an editor's choice' of Harvey Nichols products— menswear, womenswear, fashion accessories, beauty, food products and a small juice bar. The concept had to be capable of flexibility and hosting specific areas to branded concession environments."

On the display side of the equation, Four IV opted to use a mixture of fully bespoke fittings and systems from display manufacturer Vizona, which were brought into line with the house style.

"Two key elements of the design solution were image and flexibility," says Dewar-Dixon. "It was important to capture all of the Harvey Nichols Knightsbridge 'brand icons,' such as the doorman, the external projecting canopies, closed window beds [windows that don't allow a view into the store] and internal space for Harvey Nichols' strong visual merchandising techniques. It was vital to provide a simple backdrop that would display the garments to the best of their ability.

"Site-specific elements such as the 5 m ceiling heights gave an opportunity to create some unique effects—the ceiling is outlined with suspended light beams underneath the structural beams, and a large chandelier was designed as a focal point of the womenswear hall."

Particular attention was paid to directional lighting in order to highlight product to maximum effect.

"The display system was based on an existing Vizona profile, whilst all of the components were designed specifically. The wall system consists of a very slim aluminum section which is bedded into a wall panel at three hanging heights. Simple side- and forward-hanging brackets are accompanied by various bespoke items such as thick, illuminated acrylic display shelves used for accessories, floor-mounted display units provide storage, and a chrome adjustable bracket displays a single pair of shoes.

"Full-height, structural-glass shelves mark the entrance to the food hall and provide the area with a strong visual statement. Specific center-floor equipment has been developed from seating benches, jewelry vitrines, and free-standing merchandising walls, all containing acrylic branding blocks."

(Opposite top) The women's shoe department, which uses a mixture of fully bespoke and Vizona systems brought into line with the Harvey Nichols' house style. (Left) A visual for the menswear department layout and how it actually turned out (opposite bottom).

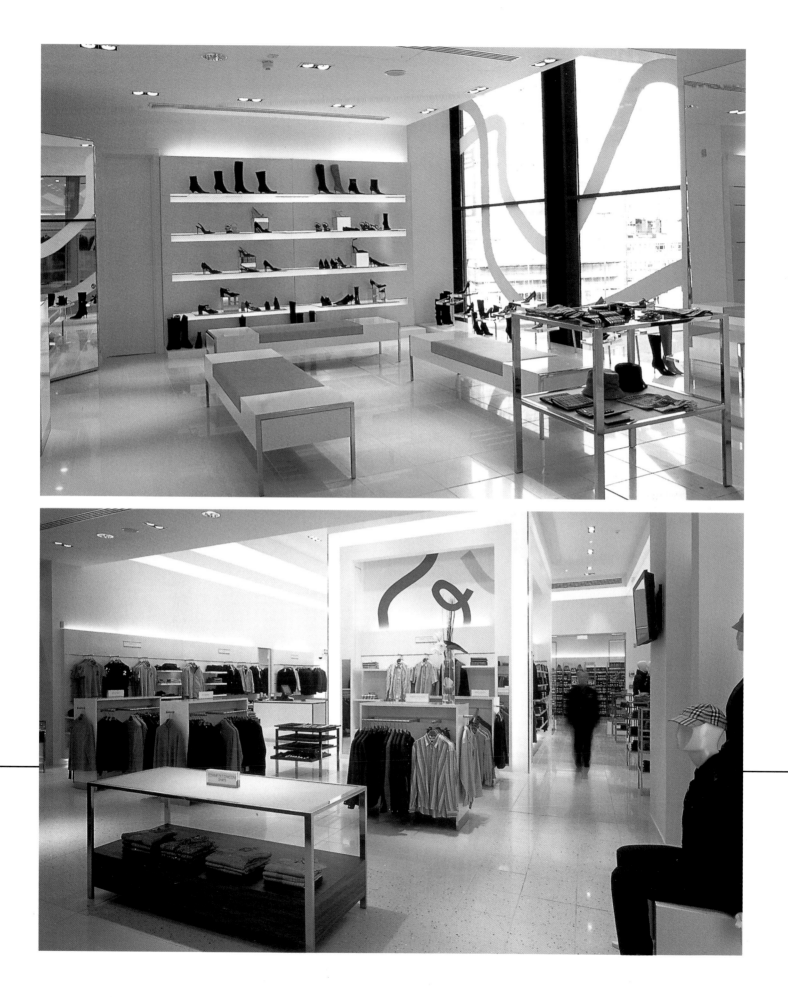

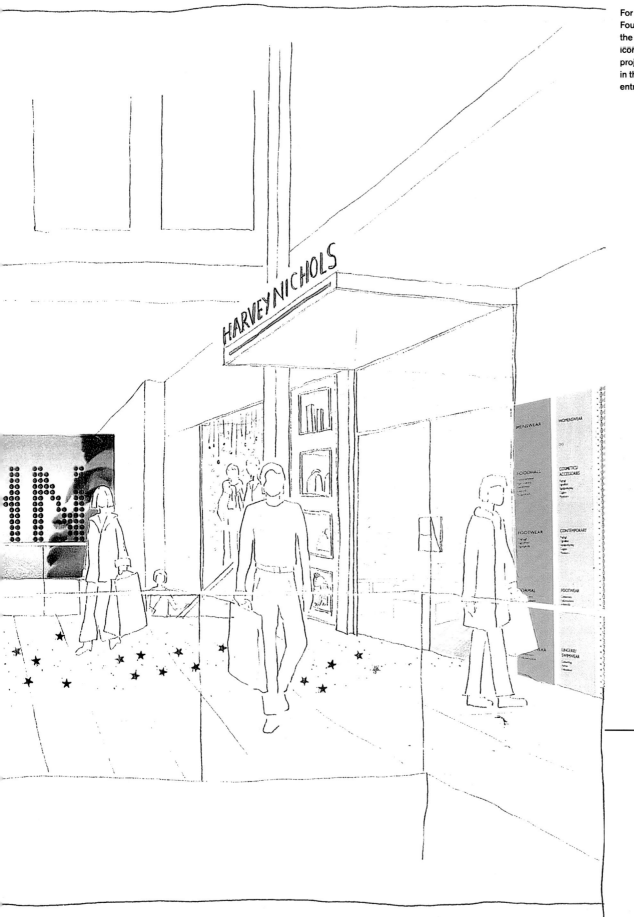

For this new boutique store, Four IV wanted to leverage all the key Harvey Nichols' "brand icons," such as the external projecting canopies seen here in this visual for the two main entrances.

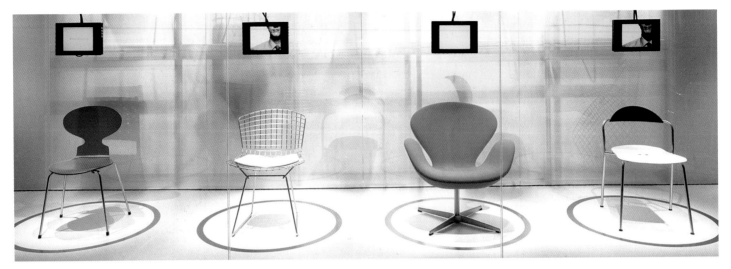

Knoll, Chicago

Displaying iconographic furniture requires a certain level of sensitivity. The right environment and the right degree of prominence will ensure that the products almost sell themselves. This is particularly true of furniture retailer Knoll's world-famous collection, which includes pieces by such household design names as Arne Jacobsen, Frank Gehry, Harry Bertoia, Marcel Breuer and Mies van der Rohe.

The display is often "talking" to an educated audience, where the customer is usually already quite design literate but is keen to know more.

Display system designer and manufacturer Alu designed and provided a variety of display supports in the creation of the Knoll showroom in Chicago, where small- and large-scale LED flatscreen technology was deployed as a communication tool, close to the products displayed.

Alu explains: "At the entrance leading into the showroom, miniature screens were suspended above chairs developed by prominent 20th-century architects. A visual history of the objects' development is thus presented.

"We designed the armatures and telescoping wands that seem to magically suspend from these screens, and in other areas, adjacent to the entrance, a pattern of various-sized screens forms a visual tapestry of moving images.

"Inside the showroom, several trios of overscaled flatscreens are suspended from the rail system, which enable the screens to be moved throughout the space as desired."

Three different Alu systems were used in this project. As well as the ceiling or wall-mounted Rail, the scheme also featured the tension-mounted or free-standing Pylon, and Frame, which can be ceiling- or tension-mounted as well as being free-standing.

(Top) Using LED screens close to the products was a key factor in the display set-up. (Above) The showroom uses screens throughout the store design. (Opposite) Flexibility was central to the scheme which uses three Alu systems.

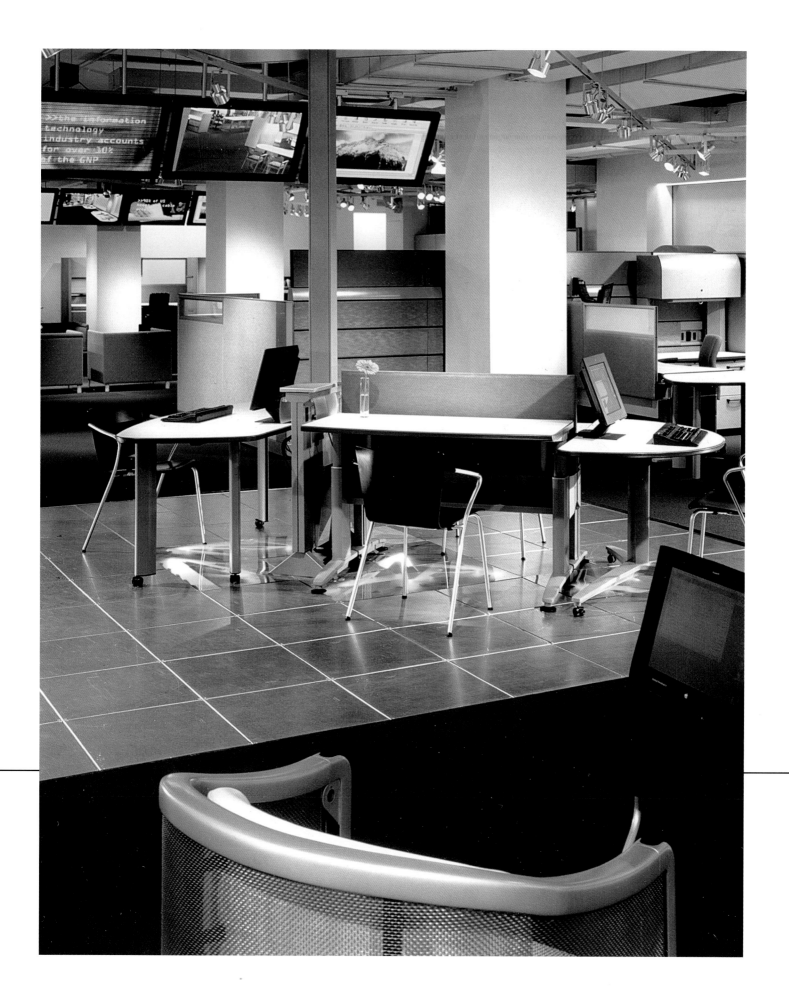

Light or dark

Retail lighting is a thorny subject for some lighting designers, who hold retailers responsible for bad-quality and over-saturated lighting schemes.

In reality there are many successful lighting schemes. Retail should, in fact, be a hotbed for the very latest lighting, since its retail role is all about attraction, excitement, clarity, dynamics, theater, not to mention control, functionality and efficiency. And all this in often extremely challenging environments.

Unfortunately, however, many retail schemes tend to see lighting as a bolt-on, something to be added once a scheme is finished. More and more specialist lighting designers are now getting involved, but even then problems can arise, as specifications become watered down, due to factors such as cost and availability. Lighting designers rightly claim that substituting even one fitting or lamp for another cheaper, similar version can significantly dilute the desired effect of a scheme.

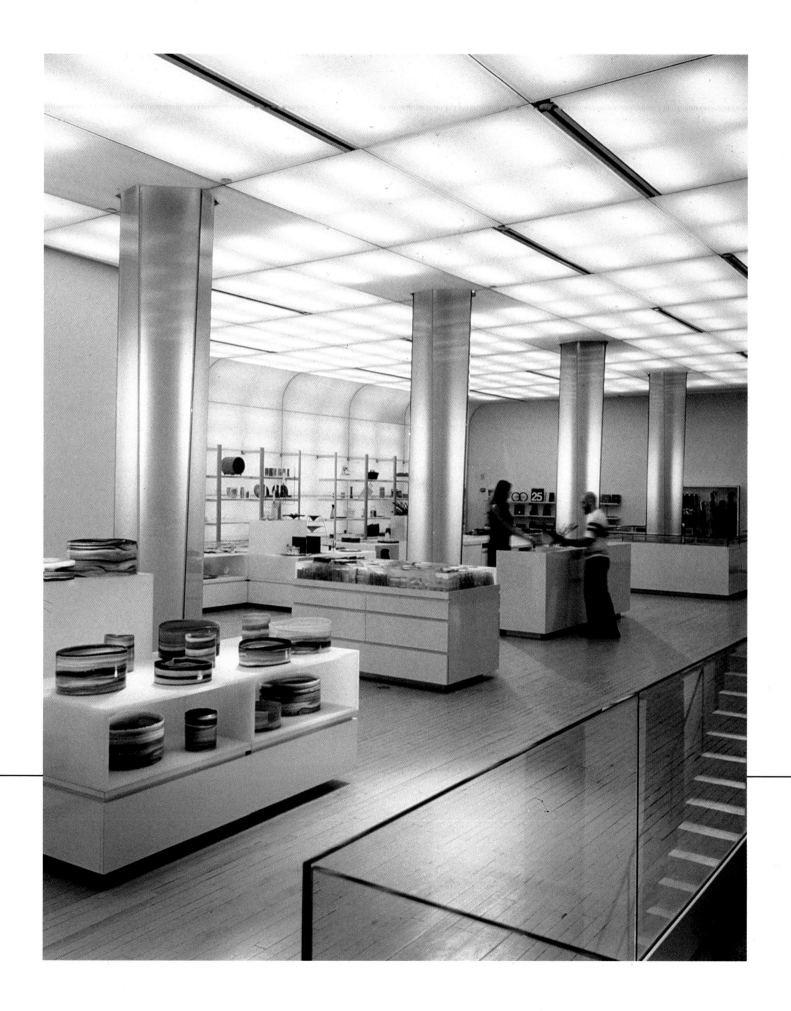

MoMA, New York

(Previous page, above, and opposite) Although some accent lighting was used, the humble fluorescent tube, hidden behind material, formed the basis of the MoMA SoHo store illumination.

The Museum of Modern Art (MoMA) in New York is a shrine to the modern age, and as such it is appropriate that it should have a retail outlet lit by the iconic fluorescent tube, and furthermore that the tube should be visible, repeated with industrial regularity again and again over the ceiling and walls. Johnson Schwinghammer Lighting Design Consultants' scheme was given an award of excellence by the International Association of Lighting Designers.

The technical challenge of lighting is at its most acute when the source of light itself is visible; slight differences in color, brightness or distribution between one fluorescent lamp and the next would be immediately noticeable to visitors. Bill Schwinghammer anticipated this, and asked for the 25 W, 3 ft tubes to come from a single batch. They didn't and had to be sent back.

The final lamps are almost hidden behind material and their positioning is critical: too close and the shape of the lamps would be too clearly visible, creating a glaring source and possibly discoloring the material; too far back and the lamp image would be softened to the point of invisibility, creating a bland interior lacking visual texture.

Schwinghammer's experience from lighting the other (uptown) MoMA store led him to realize that the distinctive forms and translucent materials of many of the products on sale meant that they looked great when revealed in silhouette, so he used the same panels to backlight the retail displays, with the lamps set further back to produce even backlighting. A subtle layering effect is achieved by gently frontlighting the goods with vertical neon tubes incorporated into the front of the display cases, whose cool white (4,000K (Kelvin))

color contrasts subtly with the neutral white (3,500K) backlighting.

A final intelligent touch is added by the green-glass shard cladding around the original cast-iron columns—they are tantalizingly visible through the frosted glass, and are transformed from functional structural forms into valuable and significant items worthy of their own display cases. Fiber optics are used to inject light into the inaccessible sealed glass units.

Color rendition is also a big issue in retail these days. People want the items they buy in the store to look the same color when they get them outside. They want those matching outfits they bought to actually match. The increasing trend towards full-height glass frontages on stores and trying to use as much natural daylight as possible helps, as does the use of lighting sources with good color rendering.

These days, lighting designers have a plethora of luminaires to choose from, as well as lamps, ranging from the traditional incandescent, discharge, and fluorescents to newer products, like fiber optics and light-emitting diodes (LEDs). Add to that all the more "theatrical lighting effects," like color-change lighting and gobo projectors, and it is clear why the market in lighting control systems has taken off in the last few years.

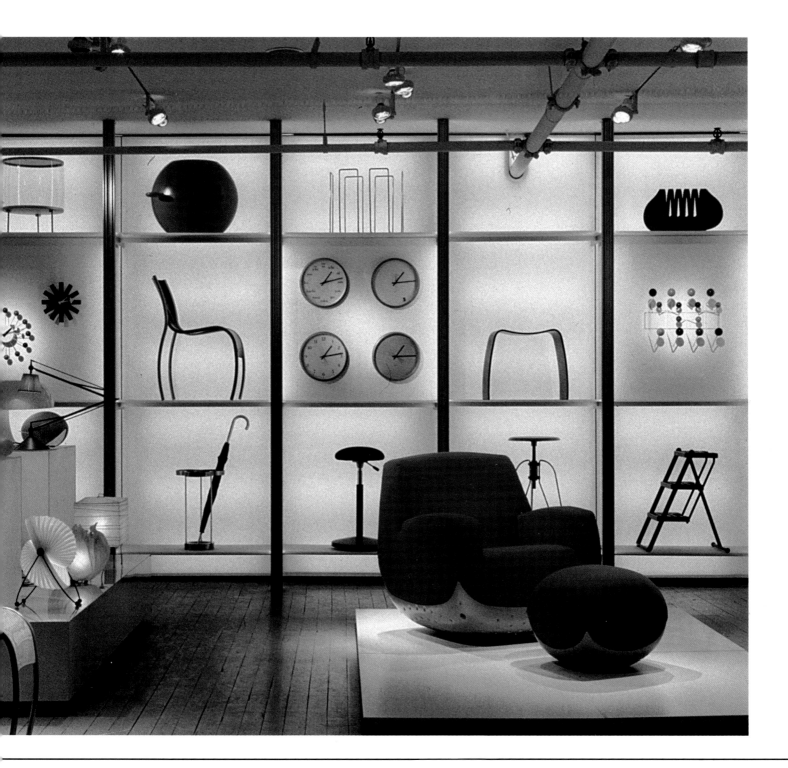

The new levels of control are a very powerful weapon in the fight for good lighting. Take the example of store windows. Invariably they are overlit, as they attempt to vie with strong daylight. The lighting is usually more effective at night, but by then a lot of the stores will be closed and the windows' pulling power is almost pointless.

"Windows must act like a magnet: attracting, enticing, intriguing and drawing people in," says Harry Barnitt of lighting manufacturer Zumtobel Staff. "Brightness is one solution, which is fine if your window stands in isolation. It's less of a solution if you're in a row of shops—the resultant 'brightness competition' can be a startling sight.

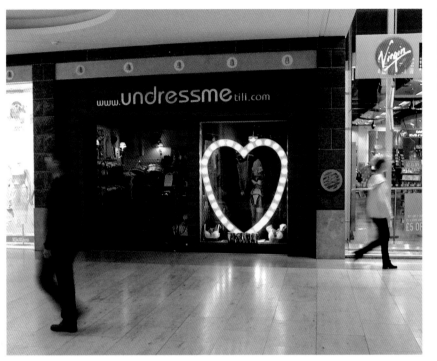

(Opposite) Wall sconces with incandescent lights were used on the interior walls for a boudoir effect, and the unusually low level of light makes the store stand out from its brightly lit neighbors (left).

undressmetili.com, UK

"Bordello chic" is what undressmetili.com was aiming for with its underwear store in Bluewater shopping center in Kent, England, according to founder Lorraine Adams. To that end, the occasional live model is to be seen modeling the underwear in the window. And, as if that isn't eye-catching enough, the store stands out from its neighbors because of its sumptuously dark and intimate feel.

Throwing out huge bursts of light through their tall glass windows, its two chainstore neighbors are the perfect foil for a low-level lighting scheme.

After being enticed through the door, the customer sees overstuffed chaise longues and experiences a lighting scheme based on old-fashioned wall sconces, chandeliers, and a few household incandescents. According to Creative Action Design, which worked closely on the project with one of the shop's designers Maria Hipwell, this creates "an exclusive and luxurious environment for customers, in which to browse through the lingerie and merchandise on display."

The bordello feel is not an entirely new idea. Agent Provocateur in London's

Soho—classic positioning for the fashionable underwear store—has been doing it well for the best part of a decade. But it is the level of lighting which is so daring. In fact, a quick look up and there are ubiquitous lighting rafts complete with a modern set of luminaires and lamps.

Undressme is aimed at twenty-five to forty-year-old women, and has been created around the premise "*La Belle*—a French girl who moved to the city to realize her dreams."

"There is no reason why the display needs to remain the same throughout the day. Change by its nature attracts attention, and while it is clearly impractical to keep changing the window display, there's no reason why the mood, brilliance and balance of the window cannot move and fluctuate constantly. The window that's familiar in the morning but different in the evening will be making a new statement, gaining a new audience. Modern lighting controls with preset programs can organize an active lighting scheme that introduces constant movement and change throughout the day."

Another alternative that can make a store stand out in a "brightness competition" is to take light levels down a little. Undressmetili.com, has done just that, taking lighting to new lows. And many designers are saying that the way forward is to stop relying on high ambient light levels, or relying on ambient light at all, and to concentrate more heavily on task lighting to create moods, drama, and ambience. And there are plenty of other bright ideas around, as retail lighting starts to come of age.

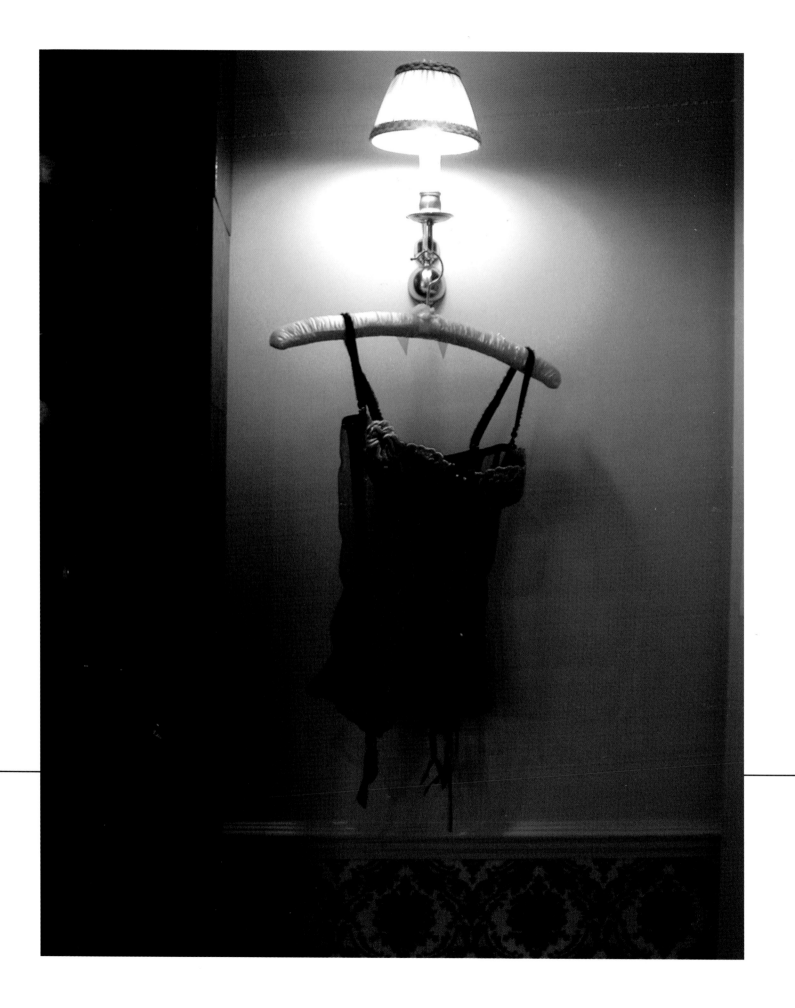

Rustan's, Manila

The complementary lighting scheme developed for Rustan's Makati in Manila, was created by Maja Olivares-Co of SSO.a and picked up a certificate of merit in the US from the International Illumination Design Awards. It also brought down the store's operating costs, with cooler-running lamps (35 W CDMRs) meaning the air conditioning didn't have to work so hard.

Rustan's is the Philippines' foremost high-end department store, and Manila-based Sonia Santiago-Olivares & Associates (SSO.a) was brought in to develop a 3D shop-in-shop environment branded as Essences, which would sell cosmetics, health and beauty, and aromatherapy brands. It also featured a Tea Bar and a spa—all aimed at middle- and high-earners.

"The exterior uses very large spans of glass to maximize visibility into the shop at street level," says Olivares-Co. "At night, the stunning lights call attention to the shop as it provides an intense contrast to the rather dark exterior environment.

"The general coloration is white, with local molave wood used in the Tea Bar furniture and walls as a warm touch to the otherwise very clean space. We also used curvilinear forms to encourage the movement of customers.

"The main lighting design objective was to provide a lighting medley—one that allows the product, the customer, and the space to glow and sparkle both inside and immediately outside the store.

"We also wanted to enhance the white and very modern interior, while also giving color-corrected lighting so that the customers could view the make-up and themselves in their true colors. It was important to avoid casting any shadows under the eyes.

"We used incandescent pendants to warm up the space in the Tea Bar and around the cash-and-wraps. In the spa treatment rooms we created indirect, energy-efficient light, which was bright enough for the therapists to work, but dim enough for the customer to relax. As well as TLD fluorescents in coves and incandescent footlights, there is a floor lamp on wheels which can be moved around and used for facial treatments."

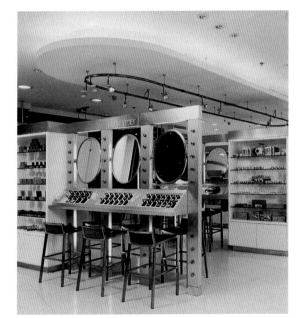

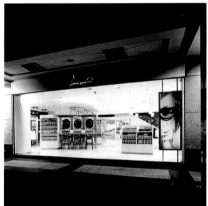

(Opposite right) The store was deliberately brightly lit to make it stand out a night. (Opposite left, above, and right) The lighting in the cosmetics areas was aimed at enhancing the whiteness of the interior, while also being color-corrected. (Right) In the Tea Bar, incandescent lighting was used to warm the space.

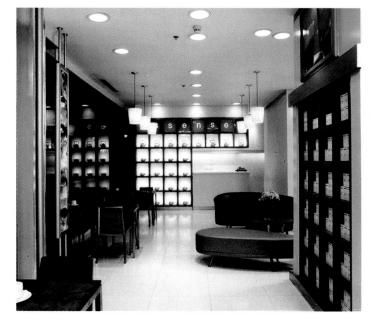

(Opposite) With such an expanse of glass the lighting scheme had to be able to work with the greatly varying degrees of light coming from outside— the scheme's ambient lighting is the result of high-pressure sodium vapor lamps. (Below and left) Pools of bright daylight-like light are used to pick out key products.

Hugo Boss, New York

Using glass in retail design necessitates careful attention to lighting. Acres of glass and transparent vistas within stores are becoming ever more frequent and they bring with them their own lighting challenges.

You can't dictate the levels of light coming from outside. There is a huge difference between day and night, and even a cloudy and a clear day, when it comes to what is happening with the interior lighting. On sunny days, perimeter areas can become very bright, creating the false impression of dark areas.

Lighting design company Lichtspiel of Hamburg has created an excellent scheme using Erco lights

for the Hugo Boss flagship store in New York City, perched prestigiously on the corners of 56th Street and Fifth Avenue. The four-story building is completely clad in glass enclosing more than 1,400 sq m of prime retail space, and light and dark zones are actually a feature of the scheme.

The glass sets the tone for an interior which is both open and minimal, allowing space for the full Hugo Boss and its Baldessarini label collections to be shown without clutter. There is also a café, Internet bar and various exhibition spaces that add to the flagship experience.

Lichtspiel worked closely on the scheme with Hugo Boss Shop Design. The dark wood fixtures and display tables contrast with the soft white walls, which are

further enhanced with warm ambient lighting from downlights using high-pressure sodium vapor lamps. The accent lighting is a nod in the direction of the store's glass-based open architecture, using daylight-like pools of illumination to pick out key products and areas. It's also used on the rear wall, balancing the light entering from the front of the store.

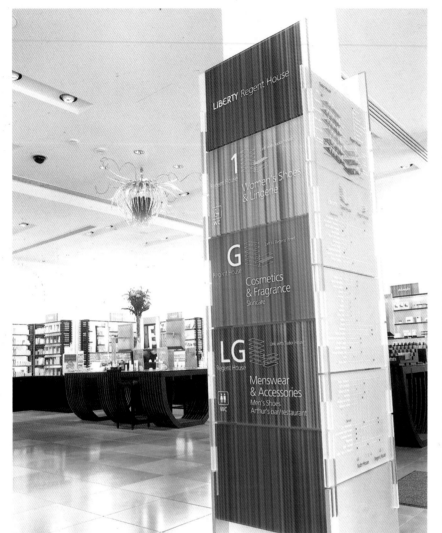

Liberty, London

London department store Liberty (pages 99–101, 146–9) closed down its operation in Regent Street (it has two joined buildings in different streets) to give that section of its store a significant restructuring that was long overdue. The result was dramatically different with a complex lighting scheme.

Liberty style is famous all over the world—a mixture of William Morris arts and crafts mixed in with a peculiarly English version of art nouveau, which flowered later than on the European mainland and drew heavily on Celtic patterns and symbols.

Liberty style emanated from the London store near Oxford Circus. The store opened its doors for trading in 1875 and the current, more famous, black-and-white "Tudor" building was actually built in 1924, soon followed by the addition of the adjoining building on Regent Street. As well as Liberty style the store has also been known for its emphasis on design and oriental items.

However, over the last decade in particular, the rapidly developing UK department store market— now aimed primarily at urban over-thirties—had left Liberty trailing. During the year-long closure of the Regent Street store, the interior was gutted and remodeled by architecture firm Landmark Retail and design consultancy 20/20.

Into Lighting Design also worked closely on the scheme. Central escalators, which dominated the space, were moved to open up the retail floor. The windows onto Regent Street were also opened up and a new, second entrance added on the corner of the building.

The client sourced a feature light fitting to make this new entrance a focus. Designed by Bruce Munro, the Sputnik chandelier uses fiber optic lighting by Schott. Measuring over a meter in diameter and weighing in at a hefty 50 kg, the fitting is basically a sphere of 190 powder-coated steel spikes topped by 60 mm diameter semi-transparent "diffusion balls." That's 190 points of light, but only one light made of fiber optics.

"We tried using a series of triangles and hexagons to get the form right," says Munro. "We even telephoned the Oxbridge universities to see if there was a theory or formula we could use! In the end we did it by eye. The eye is the best measuring tool. It's a very hands-on method."

The rest of the lighting, including external illumination, was down to Into. Inside, the lighting brief was to create "a balanced illumination with minimum shadowing and excellent color rendition. The lighting design should reflect the brand's use of materials, textures and patterns," according to Into's Darren Orrow.

(Opposite) Bruce Munro's Sputnik light forms a focus at one of the entrances and weighs in at 50 kg. (Above) One of the glass sculpture chandeliers designed by Neil Wilkin.

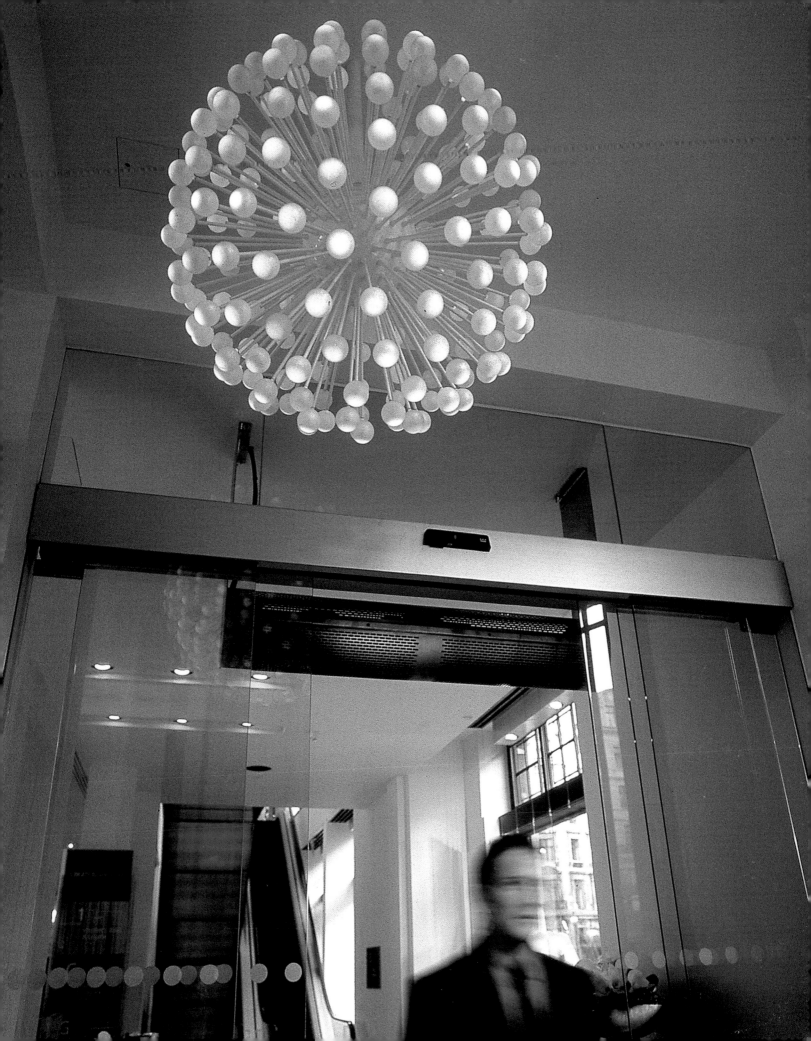

"The specification of lamps and luminaires have considered the merchandise on display and accurately render all colors of the spectrum. Light intensities have been measured to enhance the product, revealing texture and form.

"In the ground-floor cosmetics and fragrance hall, ambient illumination of the central display tables is provided from luminaires with skin-tone filters, and mirrors were designed with edge lighting so that customers are illuminated with vertical and horizontal light, reducing shadowing across the face. Feature ambient illumination is provided by concealed optical projectors that act as downlighters, projecting textured patterns across the stone floor."

Chandeliers sculpted out of glass were commissioned from designer Neil Wilkin, each one inspired or informed by a Liberty print and these are illuminated from concealed ceiling-mounted luminaires. The fragrance area is lit by a ceiling-curved translucent glass reinforced plastic (GRP) cone luminaire that projects down from the ceiling and is illuminated from a central barrisol circular light box.

On the first floor more special luminaires were also created from GRP. They are large light boxes which use a diffuser material to make them look like they are made from alabaster and glow from the inside. They provide ambient lighting and multiple direction lamps are recessed into the underside of each light box for accent lighting. The escalators, now moved to the side of the building next to the windows, are picked out in Liberty's trademark purple.

"A false ceiling void was created over the escalator to hold three separate light boxes that use barrisol translucent ceiling fabric to provide perfect diffusion of purple or white light. The lamps within the ceiling void are dimmed by a sequenced light controller that adjusts the intensity of purple diffused light as customers pass from one level of the store to another."

It is a complex scheme, whilst still remaining simple, stylish, and seamless.

(Left) Internally lit boxes display shoes on the first floor.

The big or little picture

Graphics and retail go hand in glove—graphics have always played a major part in enticing the customer, ever since the first market trader put a price ticket on the first mound of fruit and vegetables.

Graphics now adorn and pervade every aspect of retailing, from the exterior of the store, hoardings, fascia, visual merchandising in the window, to the interior, more visual merchandising, informational graphics, signage, the floors and walls, and all the way down to the packaging.

While packaging graphics and branding grew steadily together in stature and sophistication during the 20th century, exterior and environmental graphics took a little longer to get going, but with the advent of the computer age things really took off.

With advances in digital printing technology in the 1990s and into the 21st century, prices have dropped, quality has increased and the scope, not to mention the sheer size of graphics now possible has grown almost exponentially.

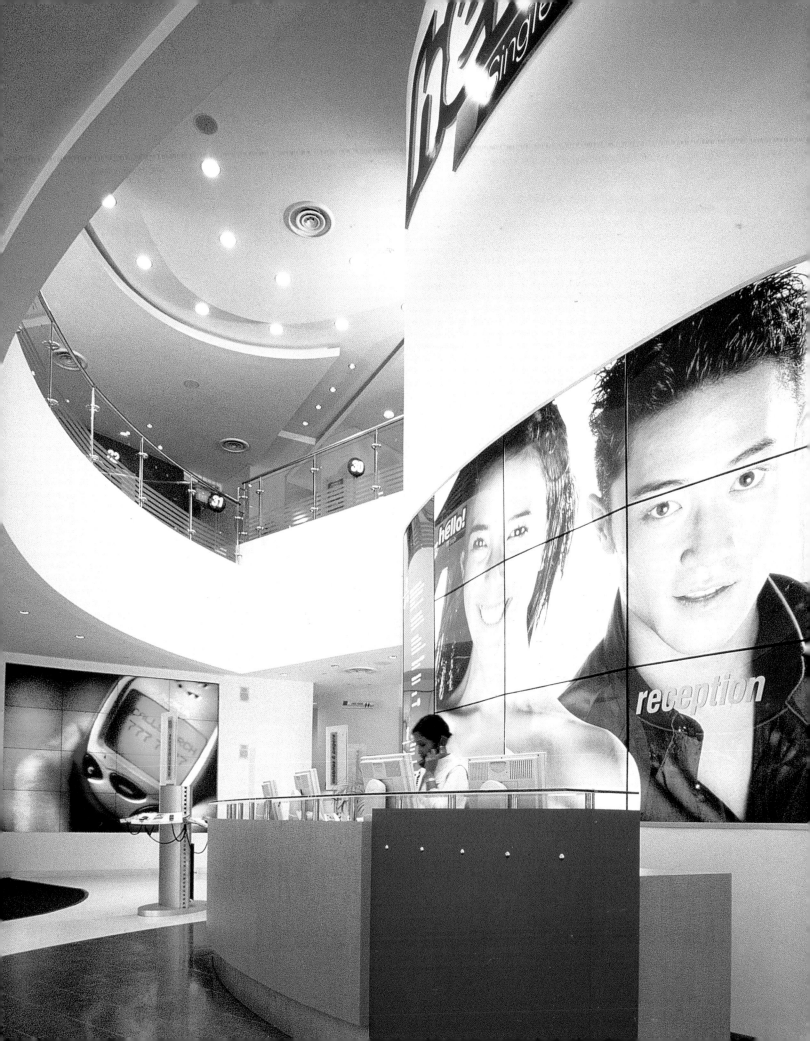

MyTravel, UK

Picture a beach with azure sky, silver sand, and a turqoise sea, and young holiday-makers having fun.

The dream becomes reality in MyTravel Megastore, the UK travel agent designed by Kracka. Its image, targeted at "young, up-for-it" holiday-makers is just part of the concept which is, at time of writing, to be translated to 750 Going Places stores in the UK in one of the largest leisure travel retail rebranding exercises ever undertaken.

"The Megastores really give us the opportunity to showcase the storytelling approach behind the concept to the full," says Vic Kass, Kracka managing director.

Kracka defined a wide range of customer sectors—from "young up-for-its" and "young romantics," to "cheap and cheerful," "cozy coupledom," "roving retirees" and so on—and the way in which they would prefer to make their holiday purchase (differing time of day, atmospheres, quiet or vibrant surroundings, etc.). "Graphics play a huge role in the MyTravel Megastores with language, color and images used throughout as part of a cohesive customer story. They guide people intuitively to the right areas of the store and the right holidays for them," says Kass.

There is a hierarchy of graphic panels including "megagraphics" (vertical and horizontal imagery, used in large welcome areas of the store to depict generic holiday images and put customers in the holiday mood); "supergraphics" (a blend of travel images and text to tell a story and evoke feelings in core lifestyle areas), and "offer graphics" (in-store graphics used at point-of-sale, and price-driven to target groups). All images for the graphic panels were shot specifically for the project by Clever Media.

A basic distinction between customers seeking value and those seeking aspirational holidays is represented in the orange and blue colorways of the logo and store concept, with the value esthetic along one wall, and bright and aspirational along the other, understated and relaxed.

On each long wall, large-scale holiday "supergraphics" dominate, targeted at the relevant customer sectors. On the orange wall these are mounted on protruding curved plasterboard separated by light boxes, and on the blue wall they are mounted on the curved walls, half enclosing the individual pods.

The graphics at MyTravel succeed in dominating, enlivening, and informing the whole scheme.

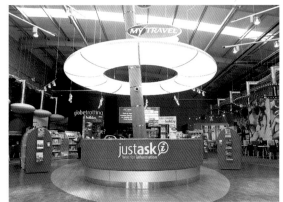

(Opposite) Huge graphics set the tone for the highly targeted offer. (Above) "Supergraphics" mounted on walls enclosing individual meeting tables and (left) the scale of the MyTravel Megastore.

Graphics can be very cost effective. In a retail world hungry for change and continually seeking to give the customer a new experience, graphics are a quick, cheap and efficient way of satisfying that need.

Large images have an undeniably huge impact, and while customers may begin to tire of them once they see them in every store and on every high street, they are still something of a novelty.

Externally, large digital graphics, especially on hoardings, are little more than huge ads. Sometimes they actually are ads, but at other times, such as when Selfridges in London wrapped its store with a commissioned "artwork" (created by photographer Sam Taylor-Wood) during its refurbishment, they claim to be more. However, even the Taylor-Wood piece was a brand statement by Selfridges, cleverly positioning itself in the market and reaching large numbers in Europe's heaviest shopping footfall area.

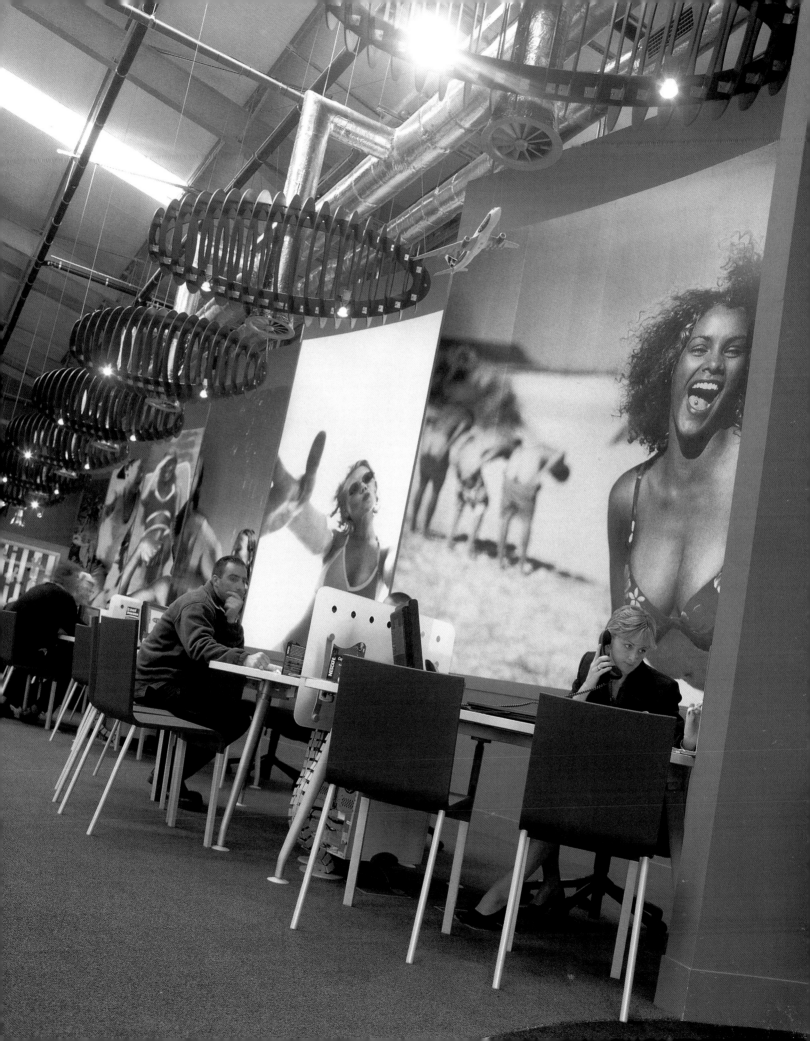

Printworks Living Ceiling, UK

Graphics and visuals play a major role in this retail and leisure complex in Manchester, created in a former newspaper printing factory by architect firm RTKL for client Richardson Developments. From the exterior to the retro ads and signage on the interior and the living ceiling, graphics set the scene and create the ambience.

Installed by Tyco Integrated Systems, the ceiling towers 23 m above customers' heads, covering an area of 345 sq m. It's made of stretched material, which looks a dull beige when the hidden projectors aren't bringing it to life. It's literally a blank canvas. When it is showing a blue sky, it resembles a stunning atrium, and looks like it is a perfectly sunny day outside. It plays several different graphic sequences: 'Star Wars'-style spaceships taking off, landing, fighting, and exploding; scenes of fireworks; Second World War aerial dogfights; scenes from the ocean; and on top of this is a nineteen-speaker system delivering 8,000 W of surround sound.

The ceiling can also play host to light shows, and the lighting system, if required, can pump out the equivalent of three football stadiums' worth of floodlights.

The Printworks living ceiling makes a step forward towards fully incorporating entertainment value into the retail experience, something which customers come to expect more and more.

(Left) A series of Philips projectors are hidden within what looks like a Victorian news-stand and project upwards onto the vast 345 sq m blank canvas that acts as a screen. (Right) The exterior, just off the rejuvenated Exchange Square, is equally as lively as the interior.

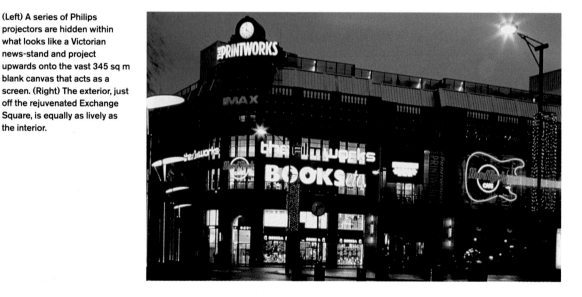

In shop windows, graphics can be a backdrop or the main event. Many retailers, particularly in the value ends of the various sectors, rely on them very heavily.

Internally, informational graphics and signage such as "Pay here," "Lingerie: Level 2," and " ♀ ♂ " not only have an essential role to play in channeling people around the store and letting them know the basics, but when used correctly and given a little thought, they are an integral part of the shopping experience and brand environment.

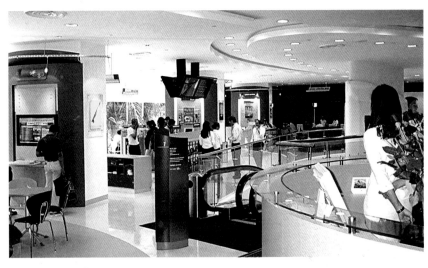

Hello!, Singapore

Singapore is a retail Mecca, and as such there is kudos attached to having the largest retail outlet in the country. Hello!, by designers rodneyfitch, is a flagship store measuring 1,189 sq m.

The store has two purposes: to provide a showcase for the new brand identity and to be a successful retail outlet for SingTel's products and services. SingTel, Singapore's deregulated telecommunications body, originally opened a chain of retail stores called Teleshop back in 1989, when the telephone terminal equipment market was first liberalized.

It brought in rodneyfitch to create a new image and retail presence on the high street. The strategy was to use its retail portfolio "to offer its new and existing customers a one-stop service that meets all their telecommunications needs," says company director Rodney Fitch. "The company then started to modernize and rebrand its outlets under the name Hello! Now all thirty existing Teleshops have been remodeled in the style of the flagship store.

"The flagship site is particularly high profile: it is situated in the center of the pedestrianized Orchard Road shopping precinct, yet also visible to nearby vehicular traffic. At weekends, 65,000 people a day walk past this store's 20m wide street frontage. The glazed façade displays color lifestyle images of people looking out of the windows, saying 'hello' to passers-by.

"These graphic images were created to allow transparency into the store at night. On the ground floor is a reception area, a mobile phone and accessory store, a new technology showcase, and a range of interactive ATM modules. The second floor houses a customer service area, an Internet sign-up area and cyber café for customers, a repair center, and a fixed-line equipment sales area.

"The interior's bright colors and curved forms are designed to give a softer image to what could be considered hard-edged technology. It has a contemporary feel—bright and buzzy with a welcome that is fun and approachable. The store has become a meeting place for eighteen to twenty-five-year-olds who can surf the Internet at weekends, although the customer profile is now challenging even the 'silver surfers.'"

More noticeable, and more influential in the buying decision process, are the visual merchandising and marketing graphics which have now reached new heights of sophistication.

"The role of graphics in retail is increasing in strength, because graphics offer a targeted storytelling opportunity for encouragement, entertainment, and engagement not afforded by any other medium," according to Vic Kass of design consultancy Kracka, which used graphics to enhance and control just about every part of the customer journey in the MyTravel Megastores in the UK (pages 70–1).

Graphic wallpaper is beginning to appear in retail environments and now the use of digital images on flooring completes the picture. Graphics are all around us in retail, and most prominently during sales season (pages 128–33).

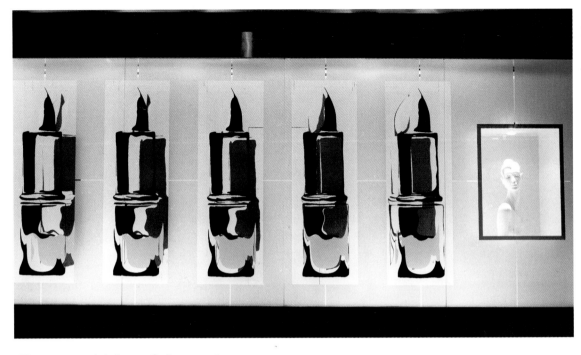

(Left, opposite, and following pages) These window schemes were multi-layered and actually only came together as a readable single image when the viewer was standing directly in front of them.

Canary Wharf, London

Store windows are great ads, and huge, immediate marketing tools for the retailer. In a slight twist of direction, the skyscraper office and retail complex Canary Wharf, brought in Kate Henderson (pages 84–7, 112–15) to dress its windows in an attempt to actually draw retailers in to the partially-let shopping center. The windows were created to show off the potential of the development while making the shopping experience better for customers.

Henderson, now a freelance designer, has been European visual director for Esprit, visual merchandising manager at Harvey Nichols and Habitat UK's national display manager. On this project she worked with former Harvey Nichols colleague Kathryn Scanlan to create windows for fourteen retail units in Tower One, right next to the celebrated Jubilee Line Underground entrance. "The design needed to be kept in line with the contemporary and clean design philosophy at Canary Wharf," says Henderson.

"Taking a predominantly graphic approach, each window was broken down into smaller viewing areas, by applying etched-glass-effect vinyl to the glazing. Through each aperture a 3D image can be seen.

"Artwork was created from original photography where the images were split into three layers, via color separation. Each element was cut out of vinyl and mounted onto individual sheets of clear Perspex. These were then suspended about 25 cm apart. From a single viewpoint, right in front, the separate images read as one, when all three elements lined up.

"Each window also had one lit showcase with a relevant product presentation backing the graphic image story. The internal walls of the windows were painted in one of a palette of bright colors and fluorescent tube lighting brought the whole concept to life. The overall effect was both dramatic and stunningly simple."

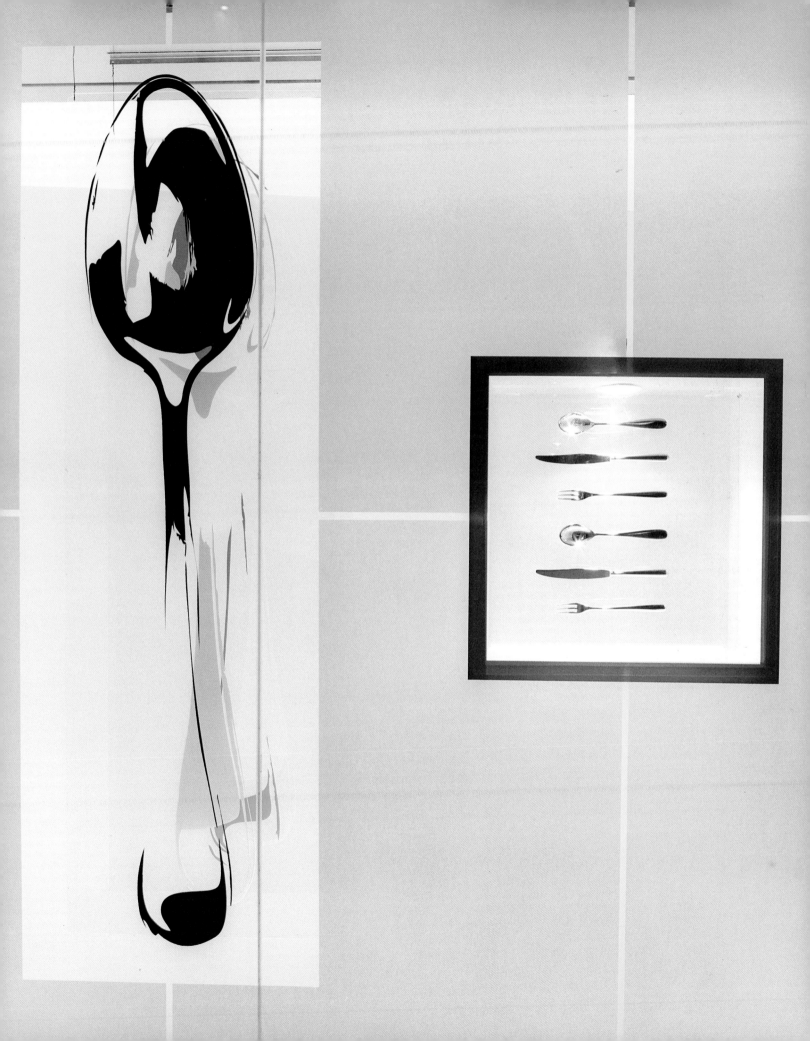

New or old

Materials affect every aspect of retailing. A marble floor can convey elegance where a laminate one signals efficiency; a silk-covered bust form is traditional where one finished in brushed steel is ultra-modern; and leather-covered display units give the opposite effect to Corian countertops.

And it's not just the materials themselves that "talk"—it's also the way in which they are used and combined. You can take a very traditional material and give it a completely new vocabulary by using it in an unusual way.

New materials or variations and improvements in old ones are also drivers of creative energy in the retail design world. Manufacturers invest heavily in research and development, backing up the results with formidable marketing campaigns. Many manufacturers have actually teamed up with designers to achieve increasingly progressive thinking around their products.

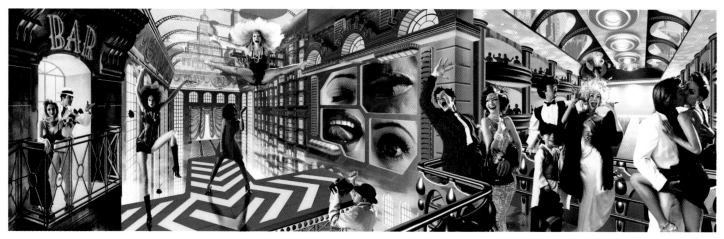

Grants, UK

Size and movement are two ways to catch the customer's eye. The world's largest lenticular image, created for Grants in Croydon, UK, is bound to attract a lot of attention. Grants has a large public atrium and the 13 m x 2.4 m high lenticular image has been designed to cover one of the structural walls within it.

Lenticular technology is capable of producing sophisticated animation effectively using up to 24 different frames or pictures. The ribs of plastic are actually convex lenses which allow you to see the image below.

The image is a mixture of historic imagery from the heyday of Grants department store—it started in 1908 as a tailor's shop selling couture garments to the wealthy—set against a backdrop depicting a highly developed Croydon of the future.

Grants department store closed its doors to the public in 1984 and was

bought by Richardson Developments, which appointed architecture firm HOK to create a leisure destination in its place.

Tony Greenland and Michelle Broomfield, of HOK's retail and leisure team, devised the original concept for the imagery. "The interactive nature of

lenticular technology is its strength. Everyone sees something different at different times depending on their movements," says Greenland.

The panels were designed by Gerald Taylor, an illustrator from New Zealand best known for his work on the 'Lord of the Rings' films. These were then worked up into the final article by Chrysalis Retail Entertainment and Service Graphics.

(Opposite) A detail of the world's largest lenticular display which measures 13 x 2.4 m. (Right) A work in progress sketch for the panel and the finished article (above).

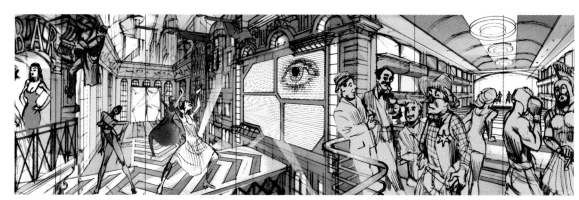

These designers create projects and products which, while they may not be aimed at any particular market or even make it into production of any kind, highlight the material's strength. A good, and by no means unique, example of this is design consultancy Bobo's (page 94–5) work with the material Perspex.

As a natural part of the creative process, designers, architects, and visual merchandisers always look for something that will add a new level of individuality to a project, something that has not been seen before, to give it the "wow" factor.

Props and visual merchandising specialist Minki Balinki (pages 90–1) bases its whole business around trying out new materials—it was behind the introduction of a new metal material to Louis Vuitton's displays (pages 112–15), a material which, while beautiful in this context, had previously been used as a filter in sewerage plants!

Design consultancy Brinkworth's (page 92–3) entire concept for the front window of the Karen Millen clothing chain flagship store in Knightsbridge, London, is based on another new material, an architectural window film, which

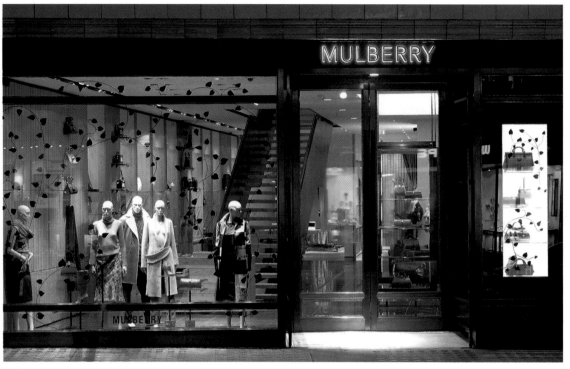

Mulberry, London

Fashion brand Mulberry wanted to do far more than just create a flagship store on Bond Street in London. It wanted to use the opportunity to reposition the brand—to modernize, without losing any of the heritage values associated with the brand (in actual fact, the Mulberry brand was born in the 1970s). Key to keeping the heritage values at the forefront of the brand experience were the materials used for the new store, particularly hand-stitched leather, as well as bronze, porcelain, and oak.

"The design of the store came from the brand-positioning exercise which defined Mulberry as English, inspirational, and aspirational," says Chris Dewar-Dixon, managing director of project designer Four IV. "Therefore, a number of traditional English crafting techniques were employed within the store design, starting with the external façade where a solid bronze shop front holds one piece of glass in position."

Hand-forged gates representing twisted vines are opened during the day to represent an "arbor" type entrance into the store. Every opportunity is taken to explain the tactile quality of the product, such as the real leather door handles into the store.

"The project looked at all aspects of the brand from corporate identity, packaging, advertising, to the flagship store design and manuals for concession environments. The site on Bond Street was only trading on two floors. We opened up the basement and extended the first floor. Major structural works were required to install the central

feature, a leather-clad staircase which links all three floors and is topped by an amber glass skylight.

"The floor plan itself was narrow and deep, so the shop front was opened up in order to connect with the street outside, and the layout was formulated to push the retailing system to each side of the store allowing maximum view through to the back of each floor.

"The components of the merchandising system all utilize the 'English with a twist' mentality; butt-jointed English oak center floor units are topped with hand-stitched tan leather, while the wall system is based on fluted tan leather wall panels, which hide a slot channel system.

"Plaster wall tiles have also been created using an old Mulberry wallpaper print, 'burnt' into the plaster. Textural materials play a big part in the image, helping to create a truly unique environment."

allows views into the store but goes opaque when viewed front-on. The same film allows images to be projected onto the windows at night.

"A lot of projects look from the outside like they could be very mundane," says founder Adam Brinkworth, "but you can always do something creative." In another project, a meeting table was covered with a light-absorbing luminous Formica. During the day it glows yellow and every night it looks different as the light goes down and it shows off the imprints of hands, paper, and pens.

Brinkworth sums up his approach: "Sometimes we work with very ordinary materials, but we try to find the magic in them."

Although there is a plethora of wall and floor finishes available, this section concentrates on the more unusual finishes or the unusual application of materials, which can create a statement in themselves..

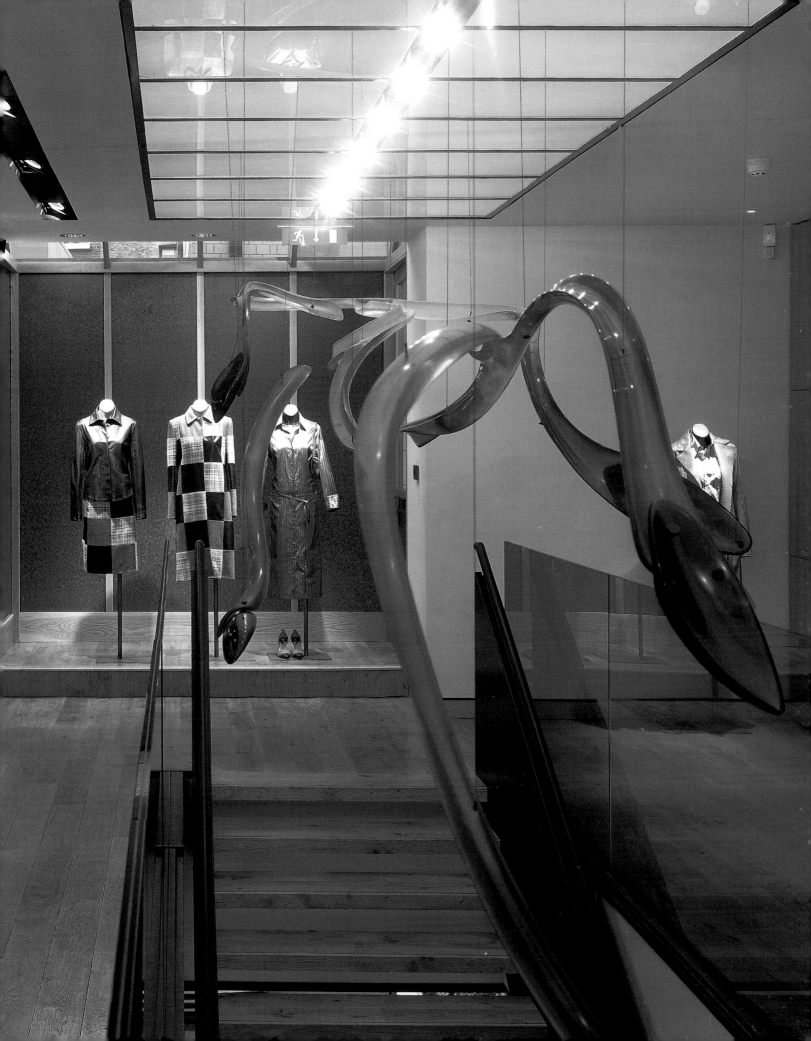

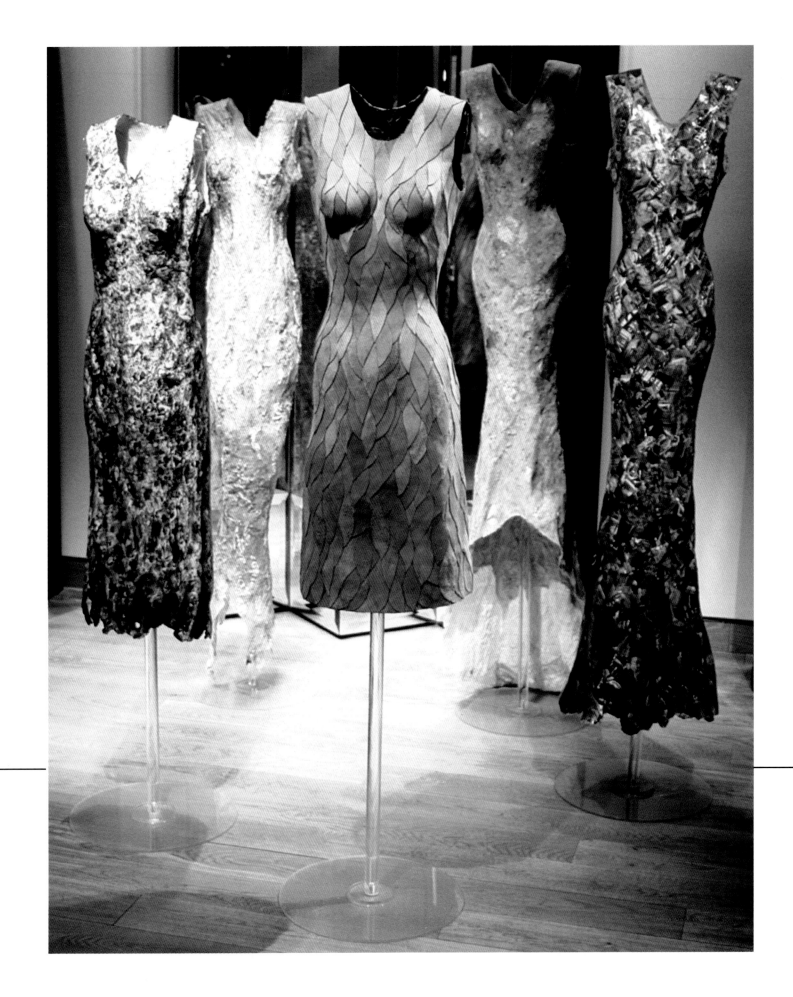

"I was introduced to Mulberry by Four IV to work on visual merchandising for the new store," says freelance visual merchandiser Kate Henderson (pages 76–9, 112–15). "Working with (mannequin manufacturer) Rootstein (cover and pages 116–19, 140–3) and (creative leather specialist) Whittaker and Malem, we developed an exclusive Mulberry design, leather-covered bust form. The leathers—supplied by Mulberry—and the stitch detail were very important, and the Mulberry tree logo was also embossed into the neck of each torso. Bronze metal stands were made to co-ordinate with the metal finishes throughout the store.

"Working again with Rootstein, an exclusive range of mannequins was developed using heads from one range on bodies from another, with a unique color paint finish and a bronze tree tattoo on the arm, neck or wrist—subtle, but it was there.

"For the stairwell, I commissioned a sculpture from Felicitas Llosa, a student at Heatherleys School of Fine Art. She created the amber-color, rippling, organic forms and artist Sara Rustin painted a Mulberry tree mural on the womenswear floor at the top of those stairs.

"I also commissioned artist Jenni Dutton to create Mulberry dress sculptures, each of which was inspired by and made from materials from the Mulberry range—scorched and torn diary pages, Mulberry brochures, remnants of fabrics and leather remnants collected from the factory floor.

"For homeware I created a display to convey the fabric design heritage of Mulberry. It needed to be dramatic and eye-catching to draw customers to the back of the store. Using Mulberry home fabrics, two full-length curtains were suspended from the ceiling. One turned into a bustled skirt that had a key jacket from the womenswear collection pinned on top (page 81). These curtains fell into a tray heaped with leaves out of which small amber tables with home products appeared.

"Mixing merchandise throughout the store was of paramount importance to help communicate that Mulberry is a lifestyle brand."

(Opposite) These Mulberry dress sculptures were created by Jenni Dutton. **(Below left)** The leather bust developed by Henderson, Rootstein, and Whittaker and Malem. **(Below right)** Minki Balinki's resin accessory display pieces.

(Opposite and above) These acid-color glass display units were used on the ground floor for the main collection, with pastel shades used for the prêt-à-porter clothes upstairs.

Christian Lacroix, Tokyo

Fashion label Christian Lacroix brought in French architect Christophe Carpente to design its flagship store in Tokyo, Japan and instantly dispensed with the cool minimalism so beloved of high-fashion houses.

The space positively vibrates as the interior is brought alive by technicolor glass display units. They've been constructed from sheets of colored glass with rounded-off corners, and the interiors fitted with stainless steel sleeves.

The taller free-standing units are made from 1 cm-thick glass sheets held together by metal bolts at the top and bottom. This means no adhesive was needed in the construction, although for this particular store it was insisted upon because of its situation in an earthquake zone.

Developed by Solutia, the glass is actually a sandwich of laminated glass with a filling of colored polyvinyl butyral (PVB) produced by Vanceva. It works with the glass manufacturers, overseeing the heat-and-pressure laminating process.

The result is perfect transparency and purity of color, and from the basic palette of ten colors more than six hundred can be made. Carpente has used eighteen hues in the Christian Lacroix store, dubbing them his "jelly-bean colors." Light diffusers have been integrated into the tops of the displays making them glow, and the metal sleeves in the units stop the colored glass bleeding off-putting color onto the clothes.

Each unit is a different color and has been grouped into acid colors—blue, green, and orange—on the main collection on the ground floor, while the prêt-à-porter clothes are displayed in calmer, pastel colors on the first floor. While striking, the translucency of the glass and the lightness of touch in the design mean that the clothes still stand out and aren't overpowered by the units themselves.

As well as having a big visual impact, the units are also very flexible. Nothing is attached to the walls and all of them can be dismantled and reconfigured into new store layouts. "Lighter" versions of the design have now been filtered down to concessions in department stores throughout Japan, South Korea, China, and France.

Minki Balinki, UK

Minki Balinki is a visual merchandising props maker which concentrates on bringing new materials into the fray or finding new uses for old ones. Set up by Nina Tillett, the company works with the likes of Garrard, Mulberry, Kurt Geiger, House of Fraser, Dickins & Jones, and Harvey Nichols, and has produced a particularly stunning "icicle forest" and other hanging props including "glitter beads," pearls, and sequins made out of resin for Harrods' Christmas windows.

"I only really started working with resin a year ago. It is a fantastic medium. It's self-setting and you can make all sorts of shapes from it," says Tillett. "Harrods wanted an ice effect so I went out and did some research into resin very quickly to get a basic knowledge of the material. I didn't fully understand the techniques, which is good because it meant I wasn't restricted by formal training or pre-conceived ideas, which I feel is so important.

"Many people are restricted by what has gone before in the sense of knowledge, structure, and boundaries.

"Experimentation is the key to successful inspiration. I spend a lot of time thinking about and trying out crazy ideas and if it turns out well I expand on it, so my work isn't contrived at all. Why read someone else's rule book when you can make your own?"

"What I wanted to do for Harrods, if I were following the rule book, would have cost double and taken twice as long to do, with the usual mold-making and casting. We did none of that and achieved something that really worked and was very individual—in fact each piece was unique!

"I did dabble with resin while at college and that's when I started to get into the use of different materials, which was a new direction for me. After initially being inspired by resin—now I find it somewhat brittle—I am now looking at a combination of different materials.

"I love working with new materials and pushing them in new directions, ones they haven't been tried or used in. Often the best discoveries are happy accidents— just think about the material and then play!"

(Above) Pieces created specifically for a Harrods' Christmas window display. (Opposite) A star is molded—experimentation is the key to Tillett's work. (Left) Feathers and resin combine.

Karen Millen, London

Large glass façades on a storefront are usually a perfect opportunity to showcase the products inside, but in the case of global fashion chain Karen Millen's flagship store, they are used as a giant screen on which to show art-school projections. Design consultancy Brinkworth covered the windows with a special film called Lumisty View Control Film (from Architectural Window Films), to make them opaque when viewed front-on.

"Accepted retail philosophy says that you have to have a window display. This one doesn't. It also says the entrance should be central This one isn't. And yet it all works far more powerfully to communicate something about the brand and its values," says designer Adam Brinkworth.

The 6 m high, two-story frontage looks like sandblasted glass during the day. A shadowy view into the store is all that is afforded when viewed front-on, but the window goes clear when viewed from an angle. This has the added advantage of stopping people in their tracks as they walk past.

From eight o'clock until midnight, the storefront comes alive with images produced by the Central St Martin's School of Art and Design in central London. The films were the winners from a competition set for the college by Brinkworth. The brief to students was to create "short films which are simple yet interesting and which reflect the Karen Millen style, without functioning too literally as a brand representation."

Karen Millen managing director Kevin Stanford expects Brinkworth—which has created more than fifty of its stores—to push the envelope when it comes to retail design. "There's a lot of trust in a relationship like this. It works well because we keep each other on our toes. We do not want to roll out the same shopfit over and over again."

The architectural film applied to the windows is removable, but it will stay on as long as its popularity endures.

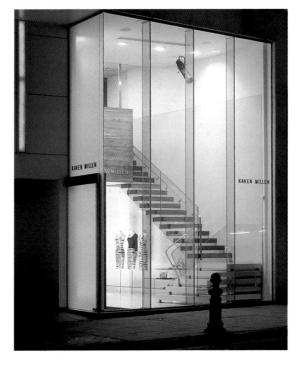

During opening hours, a window film only allows a clear view into the store when viewed head-on (left). (Opposite) At night, the same film enables the windows to become a screen for art school projections. (Above) The plan of the store shows how the entrance is offset in the main façade.

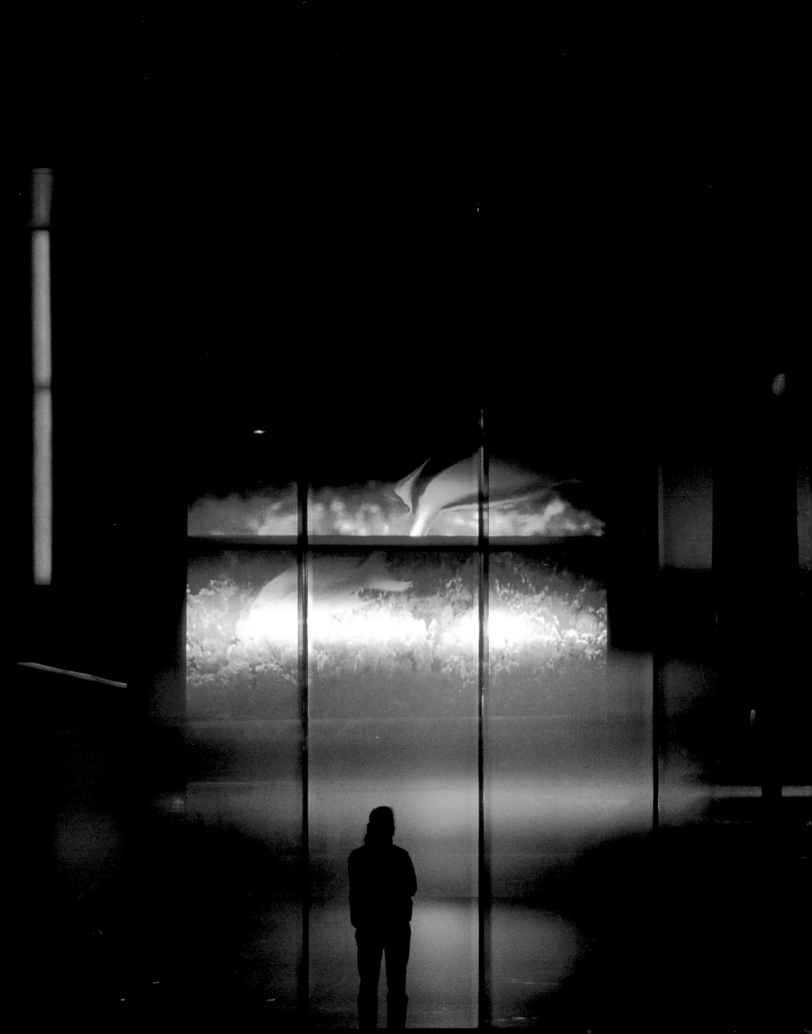

Perspex, UK

Perspex is different, lightweight, and a term often bandied around generically when referring simply to acrylic.

It is also a material with plenty of retail potential, from display and point-of-sale to signage and countertops. It looks like glass—although it's warmer to the touch and safer in many applications, and is particularly effective when back- or underlit.

Its use in retail as a lightweight alternative to glass is well-established, as is its use as a fascia material. There are now 55 standard colors to choose from. And just about any color can be extruded or cast in the material.

One project, designed by design consultancy Bobo (page 83), showed off the material's versatility. "It was aimed at unifying marketing ambitions for the 100% Design exhibition [the most highly-attended annual products and interiors show in the UK], the changing status of the Victoria & Albert (V&A) Museum, London, as a contemporary design museum, and the

Perspex brand as a material used by designers and architects," says Nick Gant of Bobo.

"We created a complete interior architecture installation for a one-off event at the V&A, made completely from Perspex. Our aim was to show the diversity of the material by manufacturing everything from cocktail dresses for the waitresses—these interacted with their environmental lighting—to enormous bars and tables to serve the 1,500 VIP guests.

"We also created giant 'living' architectural forms that combined fabric-like structures with building-scale 'outfits' containing models. All of which had to be brought through an ordinary 6 ft door and erected in just over an hour.

"The huge, central 'outfit' was made by tesselating a layer of hand-formed, laser-cut tiles into a fabric that created a canopy for the

guests—grown from the dress worn by a 7 ft tall model at the top of the piece. It was a huge success."

Perspex was first registered as a trademark back in 1934. In the 1930s and early 1940s it was used extensively as a safety glazing and lighting material, but it was the rise of corporate identity that saw the material really bloom as companies required color signs.

In the 1950s and 1960s Perspex moved into signage and corporate imaging, and worked with a newly design-conscious signage industry on corporate and more dramatic applications. Signage and fascias are still major applications for the material.

In the UK, Perspex has linked up with designer Bobo, to help show off the material's creative capacity—witness this "dress" (opposite) for a publicity event at London's V&A. Other applications include displays, furniture and countertops (above and left).

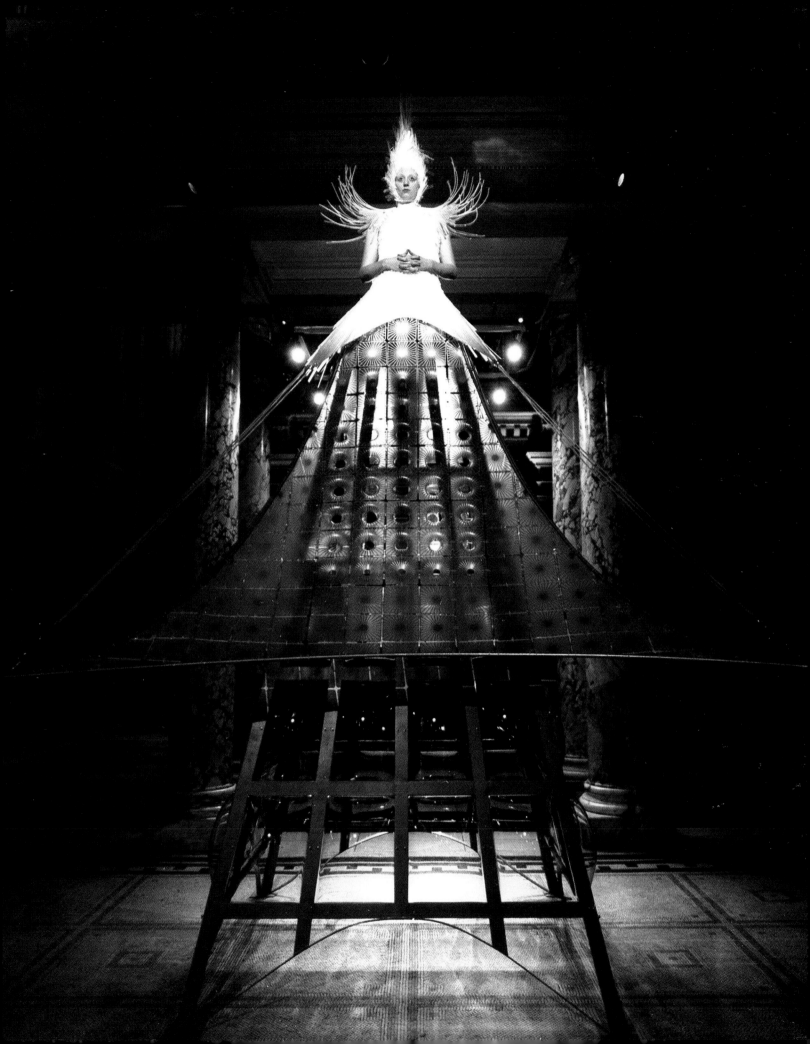

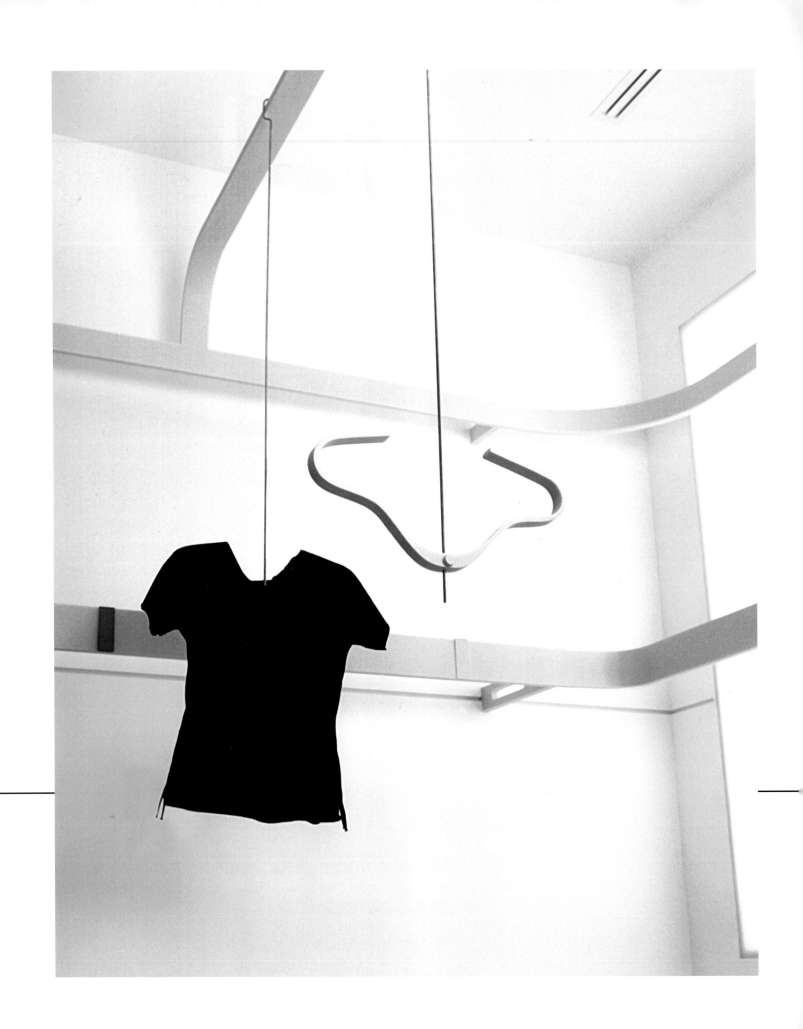

Issey Miyake, Paris

Probably better known for its kitchen and bathroom applications, DuPont's Corian is beginning to make its mark in retail, notably in a stunning, sculptural, bright white interior for fashion designer Issey Miyake.

The A-POC concept, unique to the store, was designed by Ronan and Erwin Bouroullec. It makes great use of Corian, for everything from counters and shelving to the creation of a framework of rails, which runs around the store in continuous strips. These rails act as the main store fixturing, and everything can be hung from them, including the clothes themselves, which are secured with magnets. They can also hold metal display panels either vertically or at an angle. The end result is an extremely flexible approach allowing for almost endless display possibilities.

The design of the store reflects the clothes themselves. A-POC clothes are made in a long roll—which you can see in the store—and are actually separated off when someone comes to buy them. The "continuous" nature of the clothes is mirrored by the seamless Corian surfaces.

"Two items in Corian can be fixed together without leaving a visible join," says Ronan Bouroullec when explaining why they chose to use the material, which was actually originally known as the "gold standard" kitchen countertop when it was first launched thirty years ago.

Corian's flexibility in design terms make it a favorite with the more creative designers, since it can be thermoformed and vacuum-molded into just about any curve or twist of desired shape.

Made from a combination of natural minerals, pure acrylic polymer, and pigment, Corian now features eighty colors and textures, but only one of them, White, was used at the Issey Miyake store.

(Opposite and above) One of the key properties of Corian is its ability to be seamlessly joined to give a "continuous flow," as in this Issey Miyake store in Paris.

Theater or theatrical

The worlds of theater and window display are inextricably linked—and great windows often have a truly dramatic element to them.

The similarities between the two worlds are numerous: both are required to create a sense of drama within a certain specified and confined space, each with its own unique set of constraints and challenges, particularly in classic closed-back window situations; and both have to have a set dressed to impress and a story played out within

its confines that will fire the imagination or, at the very least, hold the viewers' interest and make them feel it is worth while watching.

And the broader world of entertainment also has an input. Audiovisual display in visual merchandising is coming increasingly to the fore. With impact and a capacity for constant change—a chain can be controlled from a single location—audiovisual elements are well-established in-store and are even beginning to dominate some windows.

Liberty, London

Proving that working with a promotional theme doesn't have to mean dull graphics and a plethora of branded product, Liberty department store (pages 64–7, 146–9) managed to create some stunning windows when it teamed up with film giant Disney. The film being promoted was 102 Dalmations, which Liberty used as the basis for its Christmas windows.

Liberty took the over-the-top theatricality of the film and created its own storylines around the delightfully disgusting Cruella de Vil. Working with Disney can sometimes be a rather prescriptive experience, but Liberty's head of visual merchandising, Martin Sambrook, made it clear from the outset that the relationship would only work if he was free to interpret the theme as he saw fit.

The starting point was Cruella de Vil's mansion. Sambrook had a very strong vision of where she would live: "She's a very glamorous lady, living in opulent surroundings. So the sets depict her boudoir, bathroom, kitchen, etc. and our products are placed in the most appropriate room settings."

The theatricality of the windows was further enhanced by using scenery-painting artists from the West End Drury Lane Theatre to paint the background sets. A dalmation graphic print bordered the windows like a theater proscenium, and the black on white reversal of snow at night (white on black) helped to add a Christmas feel. The dramatic lighting was created by freelance designer Richard Rafter, who worked with Mushroom Lighting.

The dalmations themselves had to play a part in the production. One hundred and two dalmation models were created to Liberty's own design by Simon Millington & Associates and they ran amok around the windows.

(Previous page, right, and opposite) Liberty let a sense of theater run riot in these windows, which combined a Christmas theme with the promotion of the Disney film '102 Dalmations'.

While theater may have started in the windows of stores it has certainly moved in-store now as shopping and entertainment become intertwined.

For a window to hold together it has to be themed, and have a storyline. That can range from anything as simple as "it's summer and it's yellow" to "French girl goes to the city to find herself" as used by lingerie retailer undressmetili.com (pages 58–9). For retailers with a string of windows it's common to put one narrative running through the windows, linking them all together. Promotions linking in with major events, films, and licensed product launches are also a key area where a storyline is often provided, as with Liberty and its tie-in with the promotion of the film '102 Dalmations'.

Color, texture, form, juxtaposition, the mannequins themselves, movement, and of course lighting are all well-known and well-used tools in the visual merchandiser's arsenal. The use of lighting can also help to provide a sense of theater. Many scenery painters flit between the two sets of the stage and store windows.

DAKS, London

Fashion retailer DAKS' launch windows for the opening of its flagship in Old Bond Street were dramatic, intriguing, and sexy. In a twist on traditional mannequins, DAKS commissioned renowned Swedish artist Lars Nilsson to create a sculpture group, which turned the window into a vignette—a moment of exciting theater frozen in time and with all the sculptures wearing the DAKS house check.

"My previous sculptures dressed in tailor-made clothing have been made for and displayed in the white cubes of galleries," says Nilsson.

"In this case the piece was conceived for the store with an ambition for it to merge with, rather than spice up, this broader context of retail, which has been a sort of liberating challenge.

"Although it was created for the store, the installation is still an artwork in its own right, providing an innovative and fun, yet still ambiguous statement for the DAKS flagship," according to DAKS.

This stunning window installation has taken on a life of its own since the launch. From Old Bond Street it went to DAKS' parent company in Tokyo for an exhibition, then to a retrospective of Nilsson's work in Stockholm, before returning to London. It looks likely to head off again to an exhibition in Paris and a possible spell at the Tate Modern gallery in London.

Born in Stockholm in 1956, Nilsson's work—sculpture, videos, and installations—tends to explore power and sexuality. Perhaps his most famous installation—*Gå i Fångelse* or "Go to Jail"—involved him spending two months living inside a glass box on display, a comment on overexposure in modern society.

(Opposite and below) Lars Nilsson's striking sculptures provide a real sense of live theater on London's Old Bond Street.

The visual merchandiser's role is often that of creative director and can go all the way down to scene-shifter for the more hands-on individuals. Talk to visual merchandisers and they'll often quote theater as a place of inspiration—usually cutting-edge theater rather than Broadway or the West End, although even here there's something to be learned from the technically brilliant, if conventional, backdrops.

And taken to the logical conclusion, theatrical windows can become actual theater in themselves with the addition of live actors and models. It's something that has been used sparingly over the last decade but "live windows" have been in vogue, linked perhaps to the rise in voyeuristic

"reality television." They have the added advantage of always changing, of always being able to present something different to the viewer to capture and hold their interest.

Simon Doonan, the flamboyant English-born US window dresser was prompted to comment: "Real people are sure to get attention. Live windows mix window display and street theater and eventually turn into a party." (Confessions of a Window Dresser: Tales from the Life of Fashion by Simon Doonan. Viking Studio, 2001.)

adidas, London

Theatrical "live" windows are not a brand new idea; they started appearing around ten years ago. In fact, they're becoming common currency in visual merchandising. Early incarnations of "live windows" played on the fact that there was a real person, or people, in the window, perhaps modeling the latest season's fashions, but not doing a lot more. Things have evolved since then. Now retailers are going to the extreme of having real people living out their lives in the full glare of high-street passers-by.

Television had a major role to play in this live window project for adidas at Selfridges department store. During the 2002 World Cup, both of the major sportswear manufacturers, Nike and adidas, decided to take their global ad campaigns to a new level. Adidas looked to brand experience agency RPM to create a theatrical window display based on its Footballitis ads shown on television.

The "Institute of Footballitis" ads, created by Amsterdam-based ad agency 180, portray professors studying a selection of the world's top footballers to discover the scientific secrets behind

what makes some people obsessive about the game. The stars in the ads included David Beckham, Zinedine Zidane, Raul, Fabien Barthez, Ko Jong Su and Italian referee Pierluigi Collina.

The live window display took over the corner windows of Selfridges in Oxford Street— a window believed to have the highest passer-by footfall in Europe. "Inside the window, one actor performed a mixture of live football tricks and exercises whilst the other took on the role of one of the professors," says RPM director Lee Farrant.

Behind this, RPM used a backdrop of graphics and photographs of the star footballers and a looping DVD featuring the ads themselves. There was also an in-window board where the actors regularly posted the latest World Cup scores and team formations to increase interaction with passers-by.

"The brief was to bring 'Footballitis' to life with an imaginative brand experience, exploiting the fact that adidas sponsor some of the world's leading footballers. This kind of window display fascinates consumers and really added to the adidas buzz surrounding the World Cup," says Farrant.

(Above and right) Bringing window displays to life—literally. Live windows, like this adidas window in Selfridges, are becoming more and more prevalent.

Plethora or paucity

"Less is more"—a phrase coined by German-born, Minimalist architect, Ludwig Mies Van der Rohe—has been applied to just about every walk of life these days, and the idea holds a fair amount of merit as far as visual merchandising is concerned.

In fact, it is the basis for one end of the window-display spectrum, where people like fashion retailer Paul Smith deliberately keep their displays to a bare minimum, sometimes displaying nothing more than say a pair of socks, a piece of jewelry and, on one notable occasion, nothing at all.

It works for them. Paul Smith's Lance Martins, the main creative behind the stores' window dressing, says one of the best compliments he can get is a big smear on the window, where someone has pressed their nose up against it to get a really good look.

Paul Smith, UK/Japan

When it comes to minimalism with impact, fashion designer Paul Smith sets the pace. After all, there can be few window dressers who would go as far as not including any product whatsoever in its windows. During a particularly bad English summer, a note on the empty window of the Covent Garden store read, "Fed up with this confusing weather, I'm off to the Cayman Islands."

This is a perfect example of the stripped-down playfulness that typifies the Paul Smith approach to windows, and indeed the brand itself.

"The windows are meant to look like Paul did them himself—as he did when he first had the shop—in about twenty minutes," says main creative Lance Martins, who is based, with his team, at the Floral Street store in Covent Garden.

"Our approach is to keep it simple and not too serious—there's already so much stuff vying for your attention as you walk down the street, not to mention other things to think about, like your love life, did you leave the oven on?, work, money, etc.

"The clothes speak for themselves, so we don't need to create elaborate scenarios which compete with the stock—we can use the windows to convey Paul's sense of humor to passers-by." It's this lightness of touch and sense of humor which makes a classic Paul Smith display.

"We change the windows every seven to fourteen days and the ones we create in London generate ideas for our shops worldwide. They don't slavishly copy them. Each shop can create variations or just use them as a reference or for guidance—so in this way, each shop creates its own display.

"After the stock for the display is chosen, my thought process is usually to draw a (very rough) square/rectangle to represent the space. Then I think of the display as a visual story or joke, and then I decide how to tell that story/joke in the most direct way in the space."

Martins relies heavily on the use of key props, sometimes something as simple as a small white candle or toys and figures he picks up on shopping trips while he is in Japan visiting Paul Smith stores, of which there are now over two hundred.

(Right) Japanese models and toys often feature in Paul Smith windows, as in this display. (Opposite) Minimal or what? The window was empty save for this note.

Mannequin designer and manufacturer Ralph Pucci also likes to see his mannequins given a little space, used "properly" to get the message across. "Our work is very underplayed, yet it is very powerful," which also goes for his latest white, sculptural collection based on model Christy Turlington, and the stripped-down esthetic of yoga.

However, he is also a realist and knows he cannot control how they are used: "It's a big business and you have to let them go," adding, "They have a lot to say. They have a clear voice and set the tone."

Minimalism is a style and a stance, often an expression of brand value, and one that tends to be adopted by the high- to top-end retailers. It's also one which has to be done well, otherwise it can fail to involve the viewer and so the window won't perform its most basic function of enticing customers into the store.

"Dior in Paris really caught my eye, very romantic and fresh, but still possessing the grace and elegance of another time," says Erwin Winkler, creative director of merchandising system manufacturer Alu, but, goes on to warn: "Most other schemes are nice, modern, perhaps very tasteful, but rather cold and unemotional. The more emotional stores tend to skew towards entertainment themes and mass merchandising."

Inhabiting the more heavily populated end of the spectrum, mass merchandising, are the more overtly commercial operators, shifting units in large numbers. Visual merchandising here requires every bit as much creativity and attention to brand.

Working with a lot of product, which has to change continuously, also involves the visual merchandiser in a close relationship with buyers, designers, and store marketing teams. With schemes containing larger amounts of stock, the products themselves are often aimed at directly stimulating a purchase; they are seasonal, they are themed, etc., but they also have to be brought into a cohesive display—a display that works with them, and doesn't subsume them.

Louis Vuitton, Osaka

Stripped-back iconoclasm and an element of repetition were defining factors in one dramatic window created for Louis Vuitton in Osaka, Japan. Working with 10 m high windows, freelance visual merchandiser Kate Henderson (pages 76–9, 84–7) chose to fill them with three key identical things, using the full height of her canvas.

"It was window design heaven. The drama that can be achieved through having that height is amazing and it is very rare to get the opportunity to play in that scale," says Henderson.

"The design was one of three that I submitted and was chosen because it was seen as the most unique, exciting and contemporary, with a slightly 'other-worldly' feel, but typically was the most complex to deliver.

"To create the figures I worked with Albatross, an exhibitions, models and set effects company which had the relevant expertise to create the bust form. They started by sculpting a miniature from my rough sketches and then a full-scale version—1.6 m—in clay to create a mold from. It was cast in fiberglass with metal powders in and polished with metal polishes to give the illusion of shine.

"The three finished figures were delivered to graphics company Photobition (now Service Graphics), whose space I used to make all the lit oval podiums and tables that were used in between the figures to show the bags and leathergoods.

"At Photobition, we suspended the figures at the full height to mock up the fabric drops and develop the internal lighting—a blue light that shone up and out through the bands on the torso and strong spotlights pointing down to light the mannequins that stood inside the fabric.

"The fabric was aluminum, black on one side and silver on the other. At the time the material was being used primarily as a sewage filter, now it is quite commonly available from fabric shops. Nina Tillett from Minki Balinki (pages 90–1) supplied the fabric which was given a mottled, 'mock croc' finish and had Louis Vuitton monogram motifs laser-cut out in a random pattern. In the end we used over 100 meters of it.

"It was all assembled, disassembled and shipped out to Osaka. When we arrived at the store, we were confronted by a sort of rough scaffolding tower and what appeared to be a circus acrobatic troupe to help lift the forms into place. Only these very respected *tobis* (traditional Japanese workmen) with baggy trousers and split-toe shoes were allowed on the tower, and it was very impressive to watch as they manually lifted the figures into place.

"The whole glass frontage was covered in vinyl to maintain the secrecy of the project for launch, so I couldn't see a thing from the outside. I was worried about the effect of daylight on the lighting effects and overall scheme. I had to wait until dawn on the final day to pull back a bit of vinyl and check the light, and my worst fears seemed to be true—too much daylight and not enough internal light. I managed to find a local electrician and source more light fittings and the problem was resolved in time for the launch.

"I think the overall effect was brilliant. It was one of the most ambitious projects I had ever taken on and it was complicated by the overseas installation. I discovered new people who helped me develop the idea and make the vision a reality. It really did have a big 'wow' factor, both from a distance and on closer inspection of the product presentation. It certainly stopped people in their tracks to look, and what more can you ask from a window installation?!"

(Above) The height of the windows was a dream to work with for the designer, but a major challenge for the installer. (Opposite) The bodyforms at the top of the displays were fiberglass, cast with metal powder, and finished with metal polish.

With larger, more hectic schemes, you also have the issues of how to control the installation of a complex system in a chain of usually national and often international stores as well. Control and policing are other aspects of the visual merchandiser's job which are just as important in many ways as the creative side.

Every part of a scheme's installation must work and be controlled, from detailing which products are used and at what angles they are presented, right down to making sure the window area is cleaned up and the glass polished and smears removed. Then, and only then, is the window ready for the public's prying eyes to absorb it in its full glory and be stimulated enough to walk through the front doors with an urge to buy.

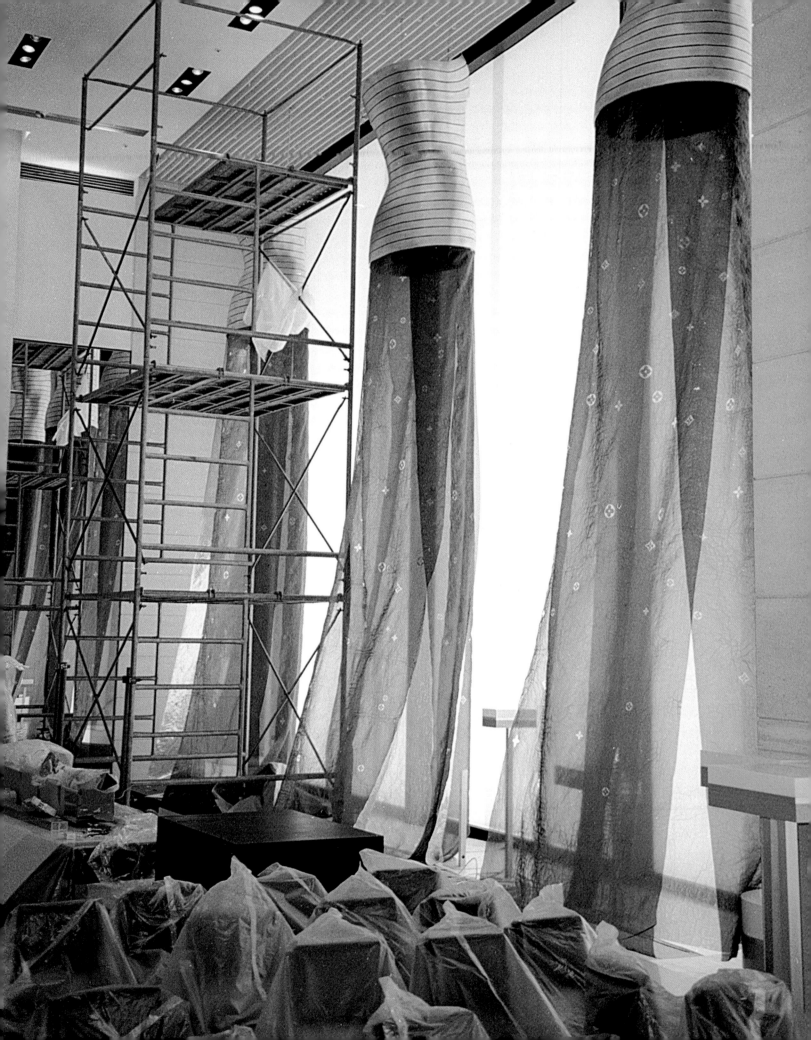

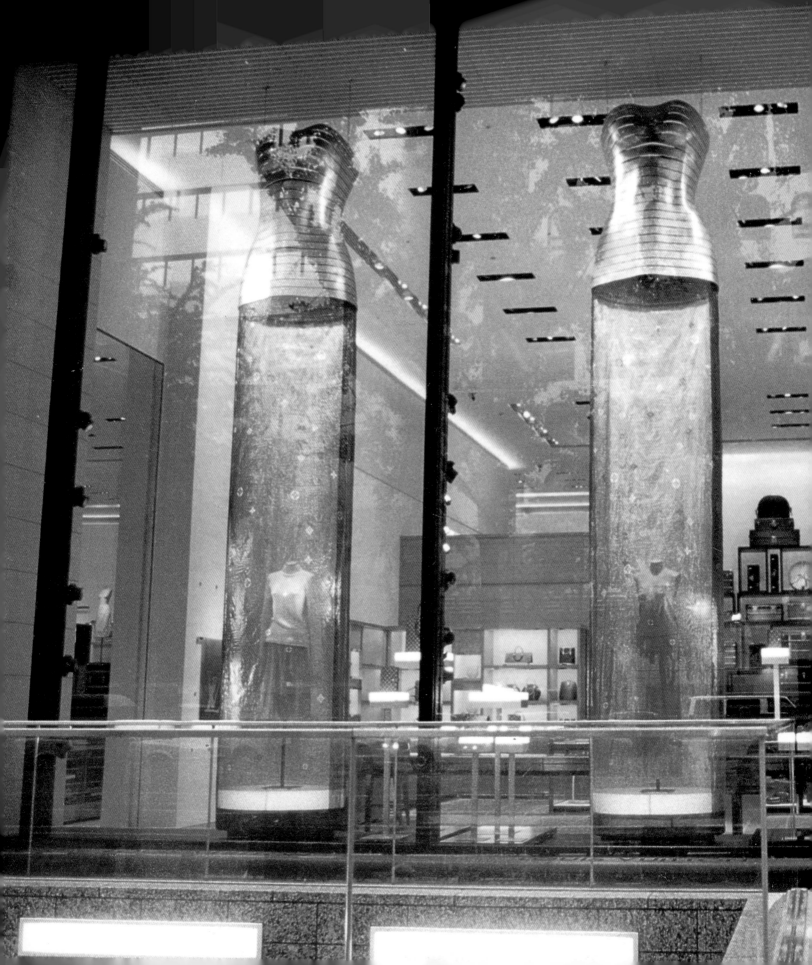

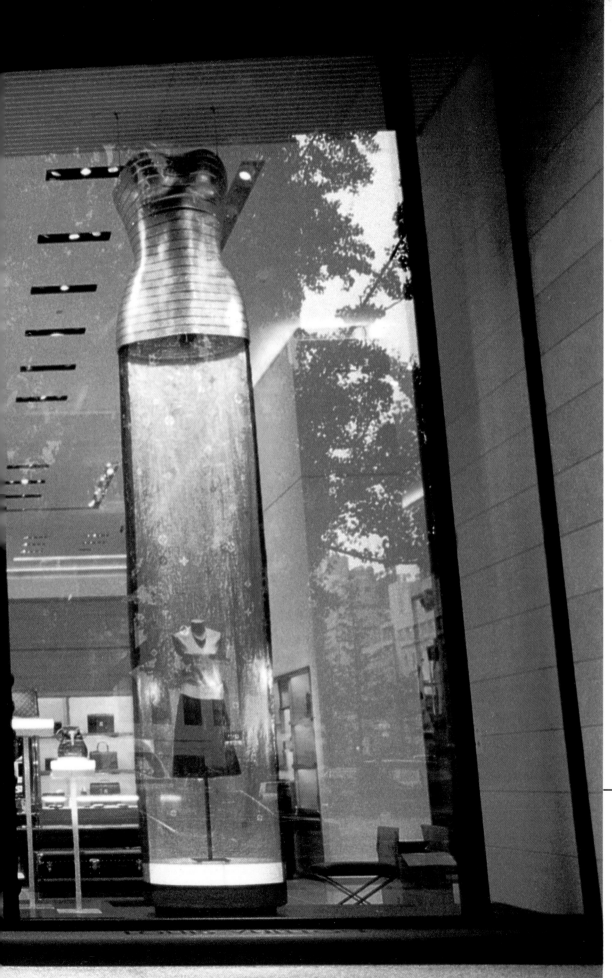

The finished project in Osaka, which was fully mocked up in the UK before being shipped lock, stock, and barrel to Japan.

Miss Selfridge, London

Commerciality is every bit as important as creativity at Miss Selfridge, a UK-based Arcadia store operating in the incredibly competitive young-women's fashion sector. The seasonal schemes created also have to work across a varied UK portfolio of 130 stores as well as more than fifty international outlets.

"Whatever scheme we do, it's got to work from Walsall to Saudi Arabia," says creative manager Matt Moss. "We turn stock round quite quickly. Designs and looks change very quickly for us. We also change the window stock every couple of weeks, so the scheme has to work with all kinds of different stock and different looks.

"When I create a scheme I go and sit with the clothing design department and go through all the key trends, which starts the ball rolling. I then talk to the buying floors. I also talk to marketing and try to link it into the marketing campaigns."

For the Miss Selfridge "Follow the Hippie Trail" summer season, Moss created a scheme based on banners, using the fabrics that influenced the hippie trends and colors, and that worked with the palette for its summer fashion.

"One thing that's important to remember is that every store in Miss Selfridge has a different-sized window; there are not two stores the same. So the scheme was structured as a kit. I produce an instruction pack for the other stores. I photograph the mock-up window from not having anything in it, right the way through until it's full, so that they know how they should hang it, what the floor should be covered in, where I want the mannequins to be positioned, angles, etc. Then everything I do for the UK goes internationally.

"At the Oxford Street store in London I can do something a little edgier and take it a bit further, but it still has to have synergy with the rest of the store chain. I redo all the mannequins and their hair and make-up. The mannequins are Rootstein (cover and pages 87, 140–3) and I work with (mannequin renovation specialists) Bodyline for the make-up and hair. We always have six to eight mannequins in each side window and we have a different look in each one.

"Because the Oxford Street windows are so high, it's difficult to always use the full height. With the summer scheme I wanted mannequins at high level, so I worked on developing a floating shelf which could be installed at any height. I was then able to sit mannequins on the shelves, giving me full use of the windows.

"I didn't want an extension wire to support the shelves as I really wanted them to look like they were floating in mid-air, so we ended up with a big metal frame behind the wall with two poles coming out clad in MDF.

"From the windows we continue the theme in store. You look at the windows, you come in, then you see another display at the threshold—this is always considered as the third window. You walk through the store and, three quarters of the way through, you've got another threshold. Here, we built a series of bases at different heights to create something which had a bit of movement to it. We also had material hanging down from the chandelier overhead, and draughts from the nearby side door kept them on the go, so that worked really well.

"The back wall is one of the most important parts of our stores—it really pulls you through. At the back we had a 3 m-high wall of graphics with a tie-dye feel, and we put swimwear with it so it became a real destination for the summer. Also, we always theme the cash-desk areas and in this case we zoomed in on swimwear shots, which really brought it alive."

REFIT STORES WITH CASH DESK IN WINDOW

18" or 12" swag to be hung on back hanging rails

Tv bubbles to be covered in window and chill out areas

Window bed

Side window Side window

Entrance Entrance

INSTALLING THE SCHEME

MANNEQUINS

All mannequins must be:

• Grouped centrally in 3's.

• 2 out of 3 mannequins looking straight ahead.

• 3rd mannequin on an angle (facing customer flow).

Entrance

(Opposite top) Giving the displays height and using large graphics on the rear wall helps draw customers through the store. (Opposite bottom) Lively graphics around the till area are taken from ad-campaign photoshoots, helping to create a synergy across the whole summer promotion.

(Above) Nothing is left to chance—an instruction pack sent to all stores shows exactly how everything should be presented. (Following pages) This scheme, with its varying levels, made excellent use of the height of the main Oxford Street window.

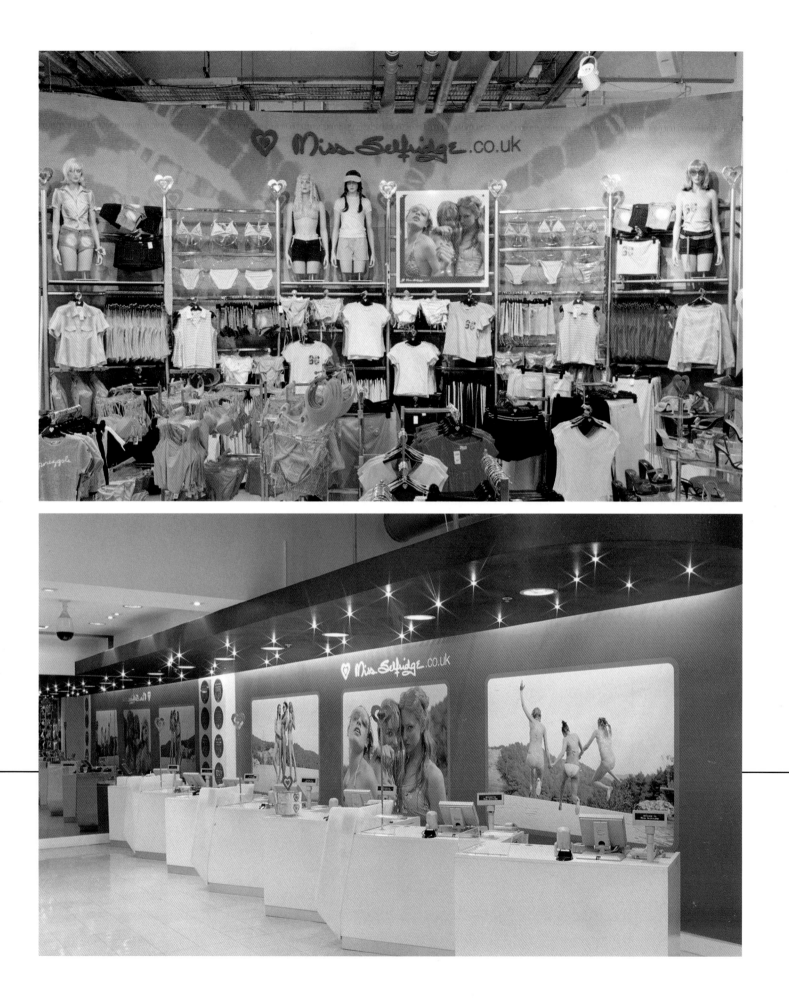

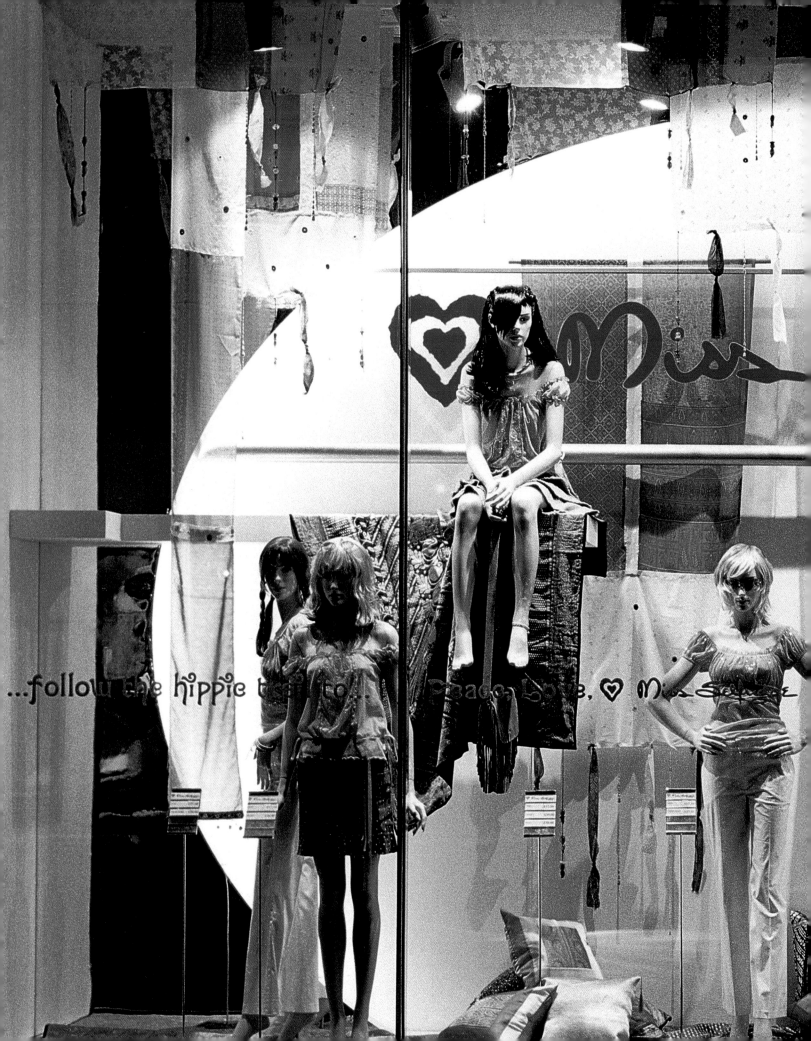

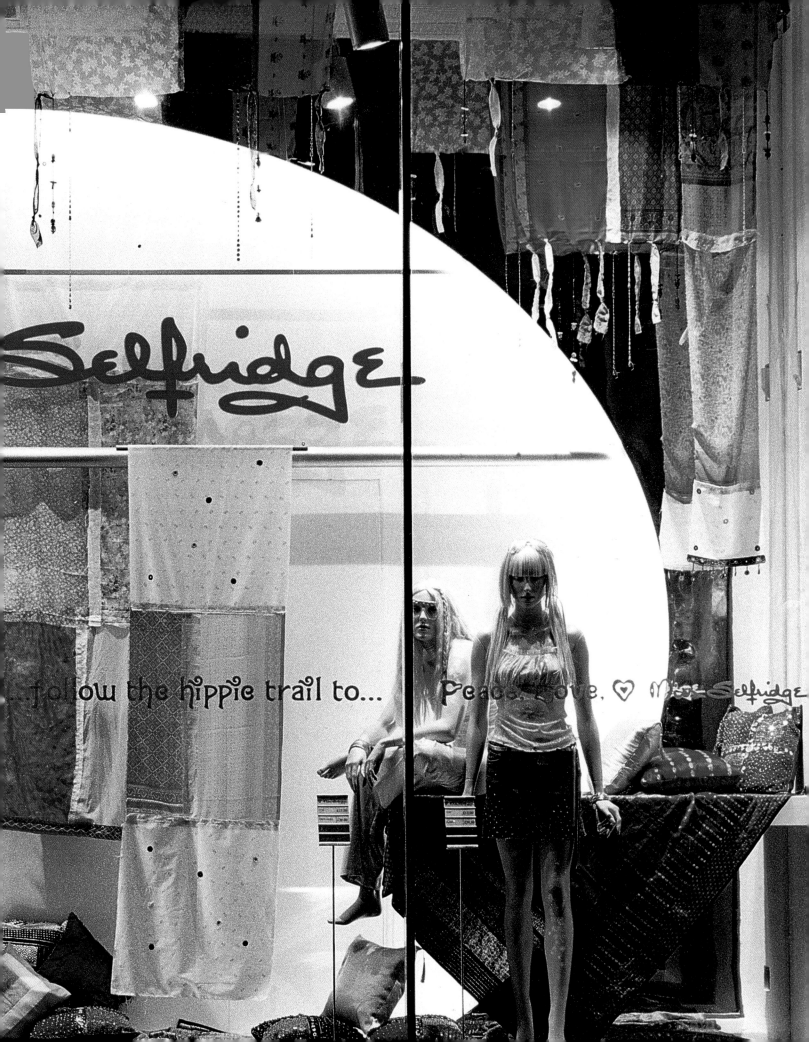

Themes

Despite selling vastly differing products in diverse environments, and using a huge variety of approaches to merchandising, there comes a point when all retailers start pulling, or perhaps that should be pushing, in the same direction.

They're not working together, but they are all working with the same visual merchandising theme—the obvious examples of this being Christmas and the sales periods, two of the biggest selling periods in the retail calendar. From a lilac, Cyclops-like, New York mannequin to a pink cow outside a London fashion store; from the cathartic reaction to a national disaster to the annual empathetic triggering of traditional responses; this section is an overview of how differently the same subject matter can be treated, and what common threads run through and underlie it at the same time.

As well as Christmas and the sales seasons, this chapter looks at some of the freshest faces in the mannequin world, and at how a very unusual charity promotion encouraged London retailers to be creative with their brand.

Themes also takes a more somber look at how New York retail reacted to and coped with the aftermath of 9/11, and it reveals a nation going back to basics and taking a new look at what it holds most dear.

Finally, no book on design, display, and visual merchandising would be complete without somehow touching on the subject of color. Many stores are using color in their lighting schemes now that technology has made it widely available.

Despite the occasional applications of new technology, in truth, visual merchandisers and designers spend their entire working lives striving to find a new angle on the same thing, trying to differentiate their work or products in a huge and increasingly competitive market. So if you like any of the ideas here, or in the rest of the book for that matter, don't "borrow" them, will you? Promise?…

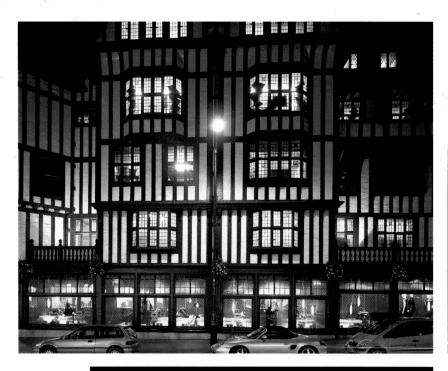

A tale of three cities: London (above left and opposite), New York (below left) and Paris (above and below).

Christmas

The period leading up to Christmas, and the holiday season itself, is a time of massive sales and no company can afford to get it wrong. Planning for Christmas starts pretty much soon after the last pieces of tinsel have been swept away from the previous year's celebration and a huge amount of effort goes into it. By the time summer comes, plans have been firmed up to the point where they're ready to go, and buying and commissioning is in full swing. Then it's into the stores any time from late October to early December, depending on the retailer.

Christmas has its own set of references to play with, from Santa Claus and reindeers to fir trees, snow, and endless twinkling pea lights. In many Western countries, it is rare for religion to be represented at all, except in the most oblique kind of reference. The majority of retailers opt for the traditional; others take the central visual tenets of Christmas and push them into new uncharted territory; while others still move far away from the central themes, for reasons such as brand positioning (particularly in the youth fashion sector) or simply seeking greater differentiation.

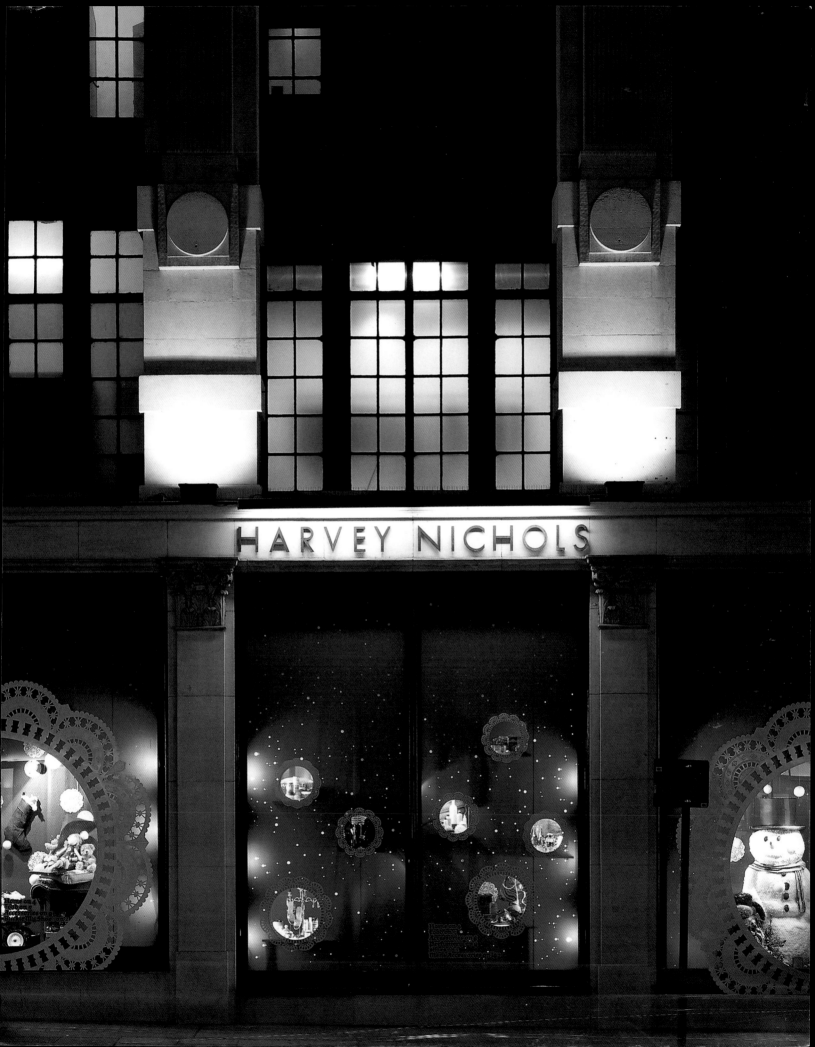

Christmas past: (Above)
Classic imagery—snow and
children in New York. Christmas
present: (Right) Luxury and
opulence in Christmas red, also
in New York. Christmas future:
(Opposite) Product, scrolling
lights, and a nod to Christmas
with a few loftily placed pea
lights in London.

Classic to contemporary: (Opposite) A traditional message in a traditional style from Elizabeth Arden in New York. (Below right) It rarely snows in London so Harvey Nichols put a snow machine on the roof to send flakes fluttering down past its snowscape windows. (Right) While religious imagery is usually kept to a minimum, angels are often considered fair game for Christmas, as at DK in New York. (Far right and below left) A contemporary take on Christmas from Dickins & Jones in London—classic whites and sparkles with an unseasonal addition.

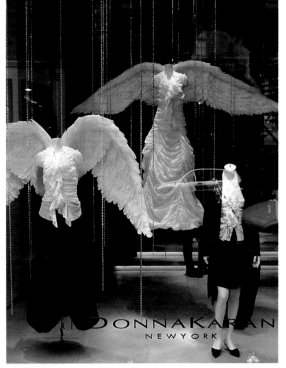

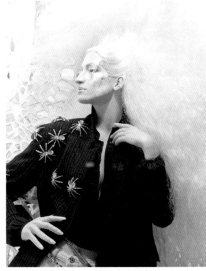

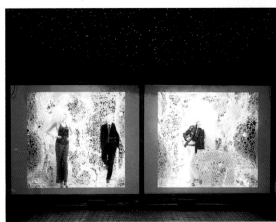

Elizabeth Arden

a New York tradition

Peace

to All

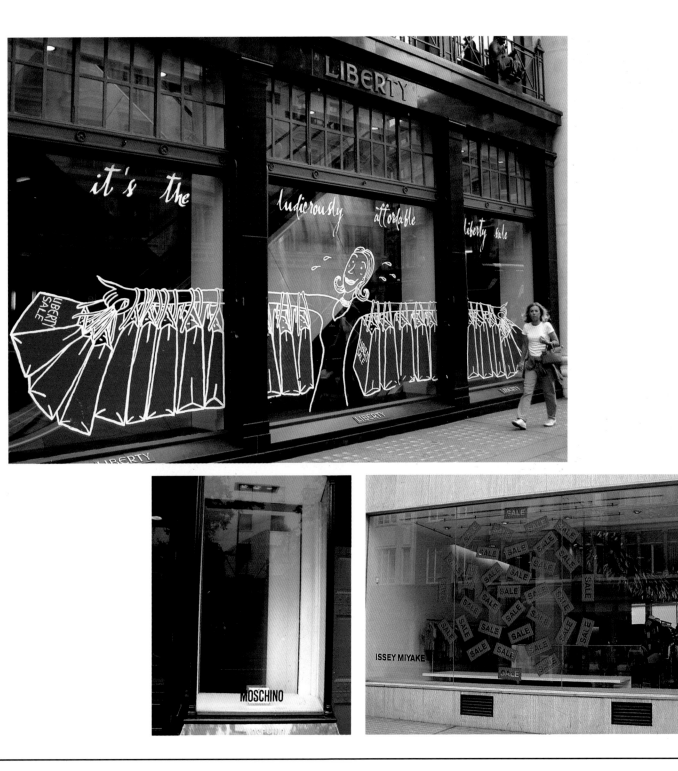

Sales

Sales are usually biannual, at least in the UK and the US. Large volumes of stock are shifted during this period. Like Christmas, it's an extremely important part of the retail and visual merchandising calendar. Today, sales displays can be an opportunity for creativity, or a resort to bold graphics which exclaim only that there is a sale happening. These graphics proudly inform consumers—usually in very large point sizes—that there is a sale, what is on sale, and for how much.

On the creative side, of which there are fewer examples, there are no specific trends except the *de rigueur* use of the word "sale." Making a creative statement about a sales promotion may even be more effective than the poster approach, since the retailer gets better differentiation in the market and it says a lot more about the brand. It is often the larger independents and fashion markets which display a novel approach to sales promotion.

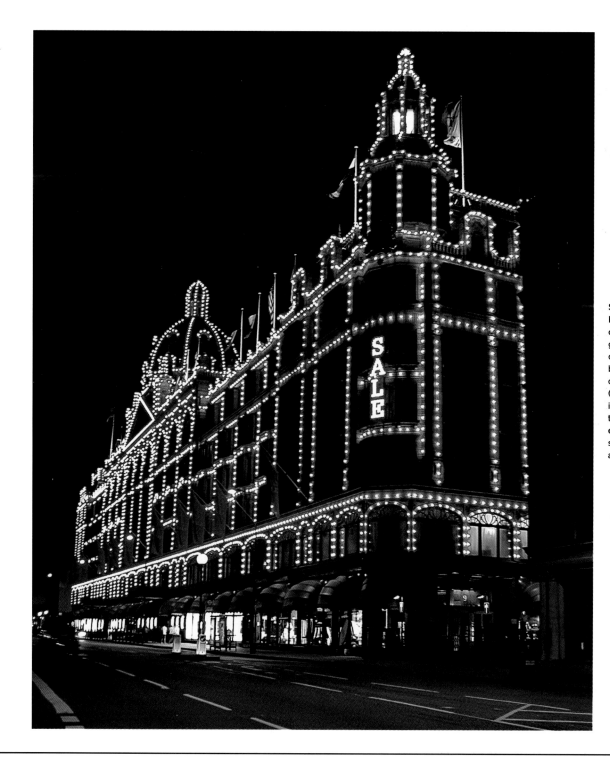

Sale away: (Opposite top) Having recently removed most of its window display space, graphics are now the preferred option for Liberty. (Opposite bottom left) Moschino opts for a cool, stylish, minimal approach. (Opposite bottom right) As with its products, Issey Miyake does the unexpected with the expected. (Left) Harrods—a straightforward, yet elegant approach.

However it's done, retailers never lose sight of the fact that this is a time for shifting units. The word "sale" must be used, be it in flowers or up in lights. (Below) Sale-customised clothing at Sharpeye. (Right) Now playing—sale, up in lights at Levi's. (Bottom) Sales made sexy and down right dirty by Diesel. (Opposite top) A feminine prescription from The Dispensary. (Opposite bottom) Say it with flowers—and just about anything else to hand— the Clusaz approach.

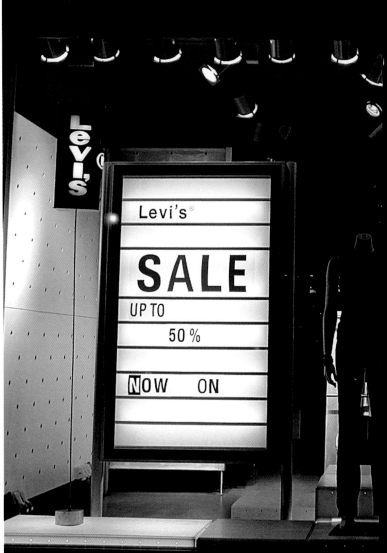

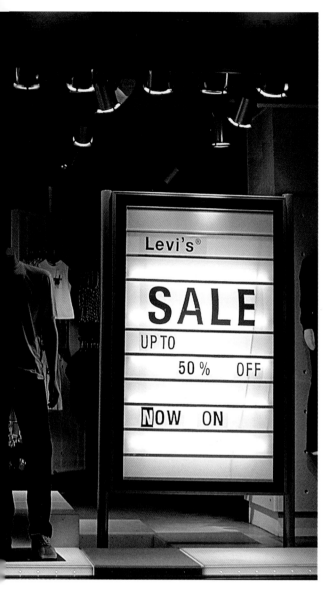

The fight between creativity and straightforward marketing of the basic principle—the sale—leads to a plethora of variations on a theme. (Left) Moschino suggests there's a sale on; (right) Fenwick shouts about it. (Opposite) Liberty uses its windows as very direct mail; (below right) Harvey Nichols is a little more oblique in its approach. (Below left) A refreshingly simple way of signing up the summer sale at Fletcher.

An extra 10% off today

ludicrous isn't it?

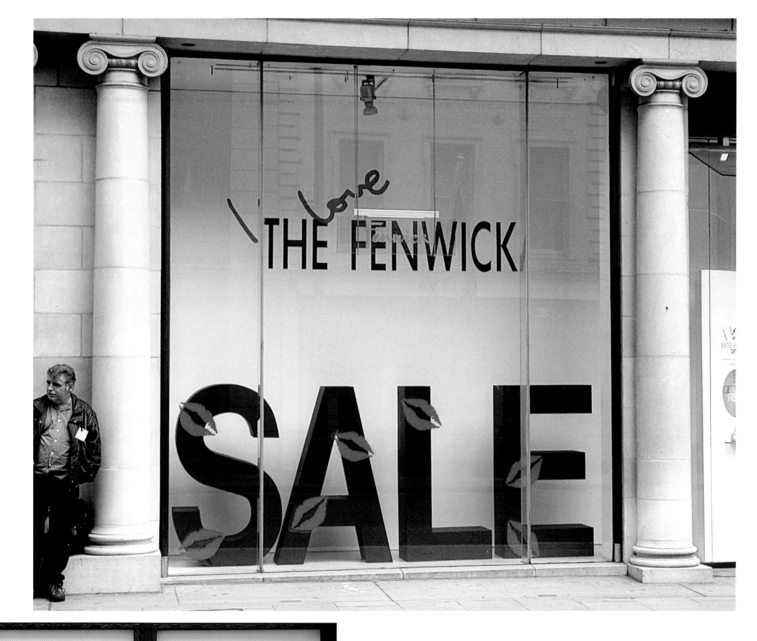

FIRE
F·D·N·Y·
ZONE

all proceeds from the sale of fire zone
merchandise benefits the new york city
fire safety education fund.
the fund supports fdny public education
and outreach programs.

FIRE F.D.N.Y. ZONE
shop on 5

Iconography: The mainstays of Americana came to the fore in New York in the wake of 9/11, as retailers tried to put out a unifying message to a broad cross section of people. (Opposite) A reworking of Milton Glaser's I LOVE NY. (Above) The stars and stripes help pay homage to the heroes of the moment—the fire department. (Right) Pumpkins, flags, and handwritten messages bring it all "home."

9/11

It is unusual for current events to actually cause the retail industry to step back and reassess. The attacks on September 11 2001, represented something completely unprecedented in the US, and globally, in terms of both the scale of the terrorist tragedy and the shocking immediacy of the way it was reported and seen in real time around the world.

The effect on retailing in New York was one of creating solidarity, and rallying around the national symbol, the Stars and Stripes. The star-spangled banner became a theme in itself as retailers across a wide range of sectors sought to deal with the situation they were collectively facing. The classic I LOVE NY graphic, designed by Milton Glaser, was also heavily reused and reworked.

The result was a visual catharsis which dovetailed into or replaced much of the Christmas visual merchandising and display in that year.

The US flag was the fallback and backdrop for many retailers, and whether overtly used in its entirety (opposite) or simply quoted (left and below), the message was still the same. (Following pages) The message was repeated in blazing neon on the streets of New York.

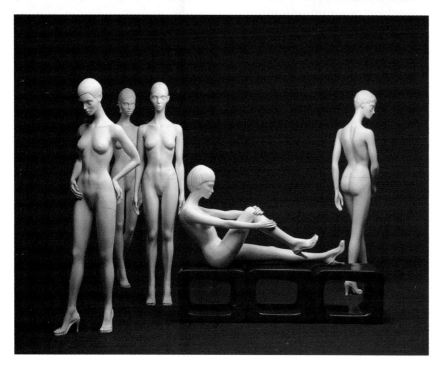

Head turning: (Left) Societa Italiana puts on a show. Heads above: (Below left) Proportion London worked with Japanese fashion illustrator Ed Tsuwaki to produce this collection. Heady mix: (Right) Ralph Pucci worked with artist Kenny Scharfe to produce this elegant cyclops and more.

(Following pages, left hand page, clockwise from top left) DLV, Proportion London, EuroDisplay, DLV, New John Nissen, Euro Display. (Right hand page, clockwise from top left) La Rosa, DLV, Rootstein, Proportion London, New John Nissen, La Rosa. (P144–5) Vamping it up Patina V style.

Mannequins

Mannequins have come a long way over the last forty years, since stores were filled with ubiquitous sallow-skinned, nylon-haired, bland models with dead eyes and chipped noses. You can still find these defunct forms gracing the windows of down-at-heel retailers.

Today's mannequins and body forms are a world away from these dummies of the past, ranging from the efficient to the ebullient. And it is commonly agreed that the watershed was down to one woman—Adel Rootstein (cover and pages 87, 116–19). Rootstein captured the zeitgeist of swinging London in the Sixties and used it to breathe life into mannequins, basing them on faces and personalities of

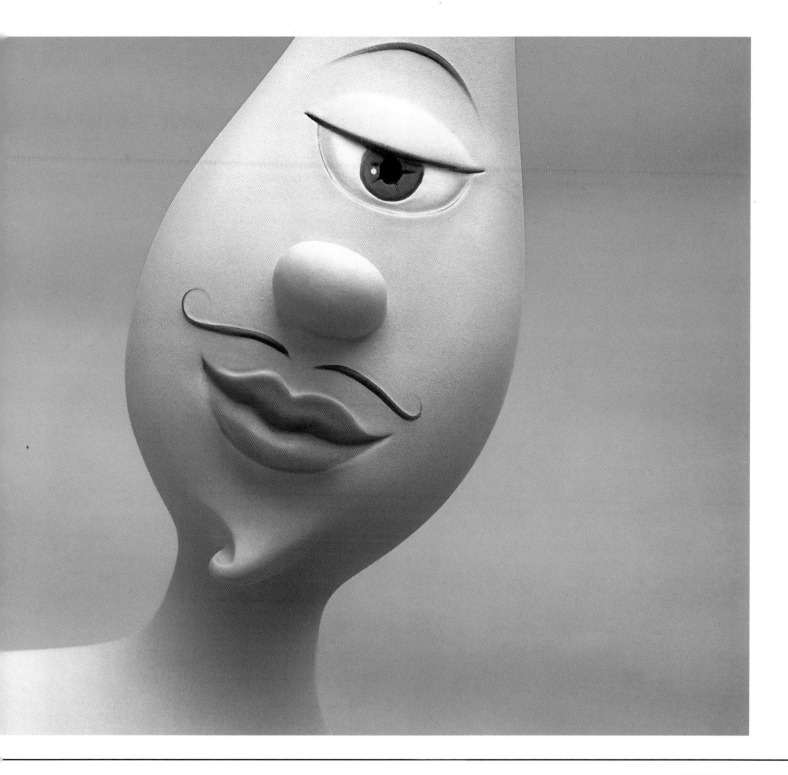

the moment. It's a tradition which has become a stock in trade for the company. When once dummies would be made of papier mâché and plaster, fiberglass became the material of choice and experimentation took hold. Now there are mannequins for every type of retailer and retailing, from the fantastical to the feminine, from the moody to the masculine.

Innovation is key and is naturally closely linked to the whirlwind machinations of the fashion industry. As the teenage market has grown, it has been matched by the advent of teenage forms and faces on mannequins, and manufacturers continue pushing to give the market something new and stunning.

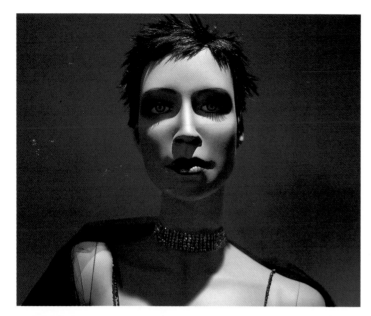

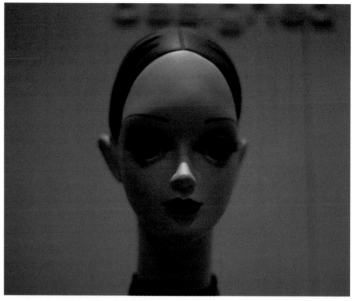

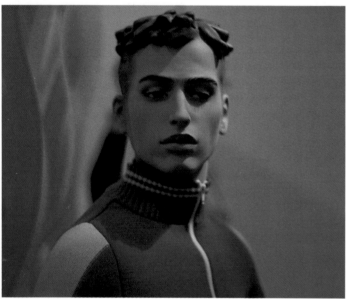

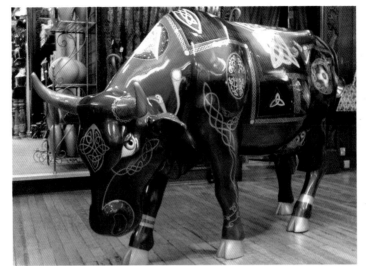

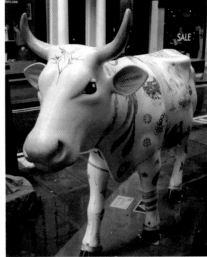

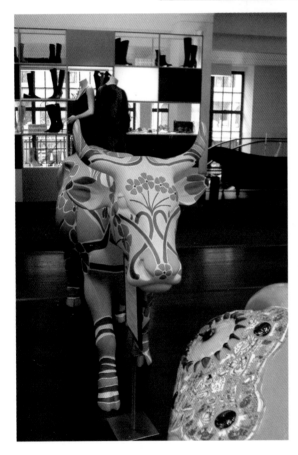

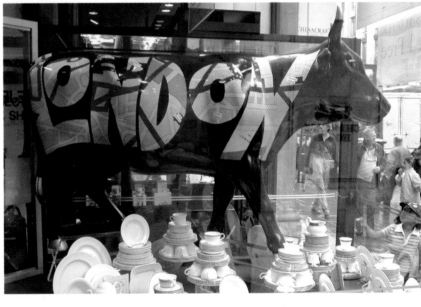

Cow parade

In a push to raise funds for charity, a series of identical white fiberglass cows, dubbed the Cow Parade, was created and then sent out to personalities, artists, and retailers to decorate as they saw fit. This afforded a rare opportunity to compare how retailers treat the same subject.

The Cow Parade was the brainchild of the then president of the International Association of Window Dressers, Walter Knapp, and the Zurich Retailers Association in Switzerland put up the money to create the cows. Knapp's son, the

well-known artist Pascal Knapp, sculpted the cows, of which there were four variants. Cows were sent to the US (New York, Kansas City, Houston), Australia, Uruguay, and finally to London. Specific retail areas and retailers, such as department store Liberty (pages 64–7, 99–101, 146–9) and silverware retailer Links of London, made their own cows more "on brand." Due to the charitable nature of the venture, however, this branding had to be done without the use of any corporate logos or lettering.

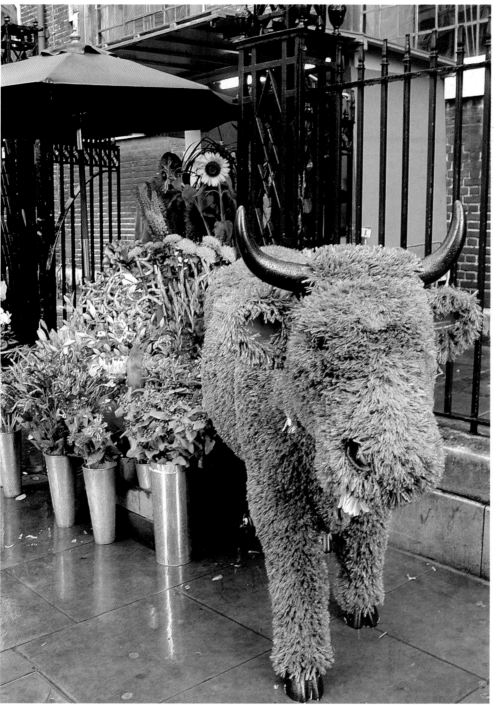

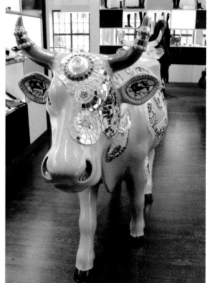

Opposite: (Top left) Celtic Cow in Liberty. (Top right) Tattooed Cow in Jermyn Street. (Bottom left) Art Mouveau in Liberty. (Bottom right) Mapped Mooer in Chinacraft. (Left) Little Mow in Jermyn Street, and (below) Cow in a china shop—actually it's in Liberty.

Liberty's design and display department created Mirabelle the Cow using a Liberty print pattern and Art Mouveau, in an art nouveau style. Links of London brought in prop maker, Props Studios, to literally brand the rump of the cow with hallmarks, as well as to give it a rather flashy necklace.

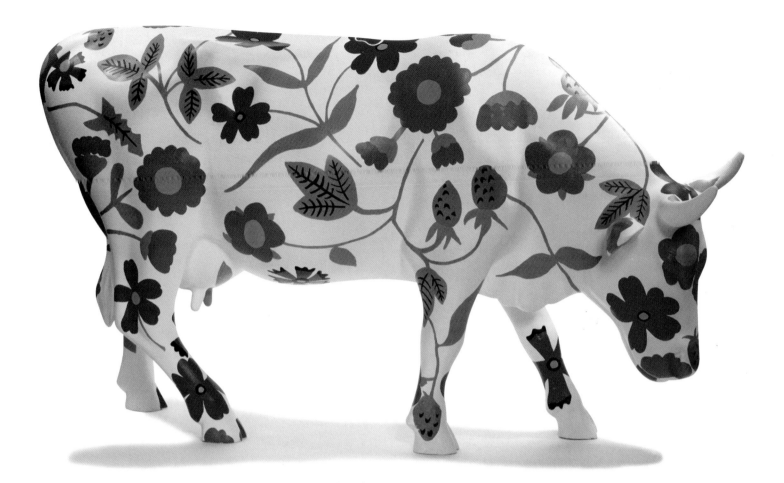

(Above) Mirabelle—designed in-house by Liberty and based on one of its own fabrics. (Opposite and right) Flash Cow was designed for the silver retailer Links of London and "branded" with hallmarks.

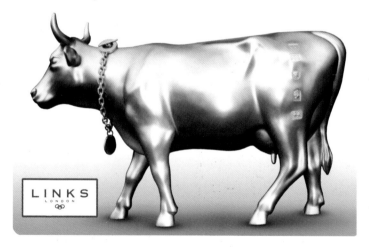

Color lighting

Retailers are continually looking for change to keep their store environments varied. Interiors often get a makeover every couple of years or so and visual merchandising changes frequently, sometimes on a weekly basis.

Change, within certain brand-conscious parameters, is common currency. It is not surprising that stores and designers have seized upon new technology in the lighting industry, such as the development of systems which can constantly change color.

RGB systems—red, green and blue, the basic color constituents of light—can offer a bewildering choice of sixteen million colors. It is important for retailers to use the technology to its best effect. One option is to choose one color each month to tie in with the dominant hue of the products on show, like the Louis Vuitton store in Osaka (pages 112–15).

(Left and below) This color lighting project for Tokyo fashion retailer HaaT was designed by Color Kinetics and is triggered to change by customer movement. (Right) Another installation by Color Kinetics, this time for Saks in New York.

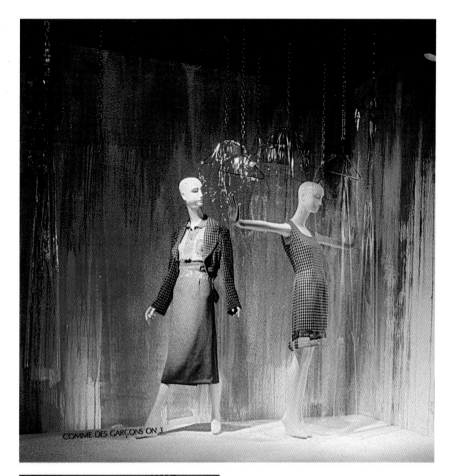

Alternatively, the colors can change gradually, and almost imperceptibly, to give different ambiences at different times of day. The colors can also be programed to alter every few seconds for a more visceral experience. Any combination is possible.

Shoppers entering HaaT's store in Aoyama, Tokyo, Japan, are the impetus for color changes. The lights in this high-end fashion retailer's store move between red and green until a customer walks in, then, triggered by motion sensors, the lighting subtly changes to yellow.

The psychology of color is a booming industry. The UK toystore The Early Learning Centre, which puts an emphasis on creative and educational toys, used university research to pinpoint key colors that calmed and stimulated children, and these were accordingly incorporated into its stores' lighting scheme.

Use of color lighting in retail environments is here to stay, but it needs to be mastered and used appropriately to create the best effect.

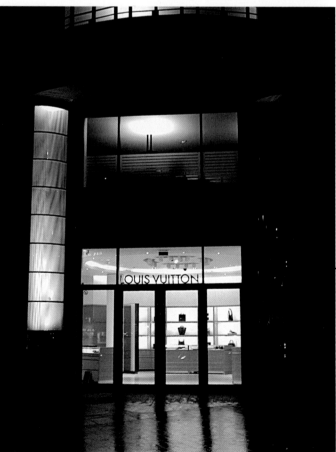

(Opposite) Martin Professional Lighting's installation for Louis Vuitton in Paris allows color change to suit new displays and seasonal collections. (Below) The color changes in this Early Learning Centre, UK, are backed up with psychological research. The scheme was designed by Into.

Variations on a theme:
Lighting manufacturer Zumtobel
Staff shows how different colors
create totally different effects
and moods.

Resources

Cover/Inside cover
Rootstein
www.rootstein.com
+ 44 (0) 20 7351 1247

Photography
Violet Martini
+ 44 (0) 20 7502 0890

CONTRASTS

P013 – 017
Prada
www.prada.com
+ 39 02 54 67 01

OMA
+ 31 10 24 38 200

Photography
Dennis Gilbert
View
www.viewpictures.co.uk
+ 44 (0) 20 7284 2828

P018 – 019
nakEd bunch
www.edtsuwaki.com
Hiruta Management Office
+ 81 (0) 3 3496 6811

Proportion London
www.proportionlondon.com
+ 44 (0) 20 7251 6943

P020 – 023
Selfridges
www.selfridges.com
+ 44 (0) 20 7629 1234

Photography
David Barbour
+ 44 (0) 20 7462 8000

P024 – 025
H&R Block
www.handrblock.com
+ 1 212 953 3800

Miller Zell
www.millerzell.com
+ 1 404 691 7400

Photography
Regnier Photography
www.regnierphotography.
com
+ 1 913 362 5599

P026 – 027
Lotto
www.national-lottery.co.uk
+ 44 (0) 8459 100 000

ID Magasin
www.idmagasin.com
+ 44 (0) 1858 461 461

P029 – 035
Levi's
www.levistrauss.com
+ 1 415 501 6000

Checkland Kindleysides
www.checkind.com
+ 44 (0) 116 264 4700

CIL International
www.cil.co.uk
+ 44 (0) 20 7272 0222

Photography
(P029, 032)
Robertino Nikolic
www.robertino-nikolic.de
+ 49 (0) 61 3 14 21 46

(P030)
Jon Arnold
+ 44 (0) 1509 416 313

*(P031, 033: San
Francisco)*
Robert Canfield
+ 1 415 472 1302

(P035: Cinch)
Adrian Wilson
www.interiorphotography.net
+ 44 (0) 7831 201 746

P037 – 039
Marni
www.marni.com
+ 44 (0) 20 7235 1991

Future Systems
www.future-systems.com
+ 44 (0) 20 7243 7670

*Photography
(P037, 038)*
Richard Davies
+ 44 (0) 20 7722 3032

P040 – 041
Mandarina Duck
www.mandarinaduck.com
+ 39 05 17 64 411

Droog Design
www.droogdesign.nl
+ 31 20 62 69 809

P042 – 043
Fishshop
+ 44 (0) 20 8960 3434

Gundry & Ducker
+ 44 (0) 20 7987 9585

*Photography
Exterior*
Christoph Kicherer
www.christophkicherer.com
+ 31 14 25 24 65

Interior
Daniel Sanderson
+ 44 (0) 7985 461 312

P044 – 045
Magma
www.magmabooks.com
+ 44 (0) 20 7240 8498

[in]side out Systems
www.insideoutsystems.com
+ 44 (0) 20 7249 8820

*Photography
(P045)*
Sean Corrigan
seancorrigan@globalnet.
co.uk

P046 – 047
Woolworths
www.woolworths.co.za
+ 27 (0) 21 407 9111

CIL International
www.cil.co.uk
+ 44 (0) 20 7272 0222

**Visual Merchandising +
Store Design magazine**
www.vmsd.com
+ 1 513 421 2050

P048 – 051
Harvey Nichols
www.harveynichols.com
+ 44 (0) 870 873 3833

Four IV
www.fouriv.com
+ 44 (0) 20 7837 8659

Vizona
www.vizona.com
+49 (0) 7621 77 00 30 00

Photography
Andrew Peppard
+ 44 (0) 779 962 7801

P052 – 053
Knoll
www.knoll.com
+ 1 312 454 6920

Alu
www.alu.com
+ 1 212 924 8713

Alu UK
+ 44 (0) 20 7400 4150

P055 – 057
MoMA
www.moma.org
+ 1 212 708 9480

**Johnson
Schwinghammer
Lighting Design
Consultants**
www.jslighting.com
+ 1 212 643 1552

*Photography
(P055 – 057)*
Peter Aaron
Esto
www.esto.com
+ 1 914 698 4060

P058 – 059
Undressmetili.com
www.undressmetili.com
+ 44 (0) 20 7731 0033

Creative Action Design
www.creativeaction.co.uk
+ 44 (0) 1727 799 999

Photography
Violet Martini
+ 44 (0) 20 7502 0890

P060 – 061
Rustan's (Essences)
+ 63 (0) 2813 3739

SSO.a
ssoa@tri-isys.com
+ 63 (0) 2893 4223

P062 – 063
Hugo Boss
www.hugoboss.com
+ 1 212 485 1800

Erco
www.erco.com
+ 49 (0) 2351 5510

Photography
www.erco.com

P064 – 067
Liberty
www.liberty.co.uk
+ 44 (0) 20 7734 1234

Into Lighting Design
www.into.co.uk
+ 44 (0) 20 8877 1707

Bruce Munro
+ 44 (0) 1749 813 898

Photography
(P065: Bruce Munro)
Andreas Schmidt
+ 44 (0) 7973 301 314

Photography
(P066: Neil Wilkin)
Keith Parry
+44 (0) 20 8983 0044

P069 – 071
MyTravel
www.mytravel.com
+ 44 (0) 161 232 6464

Kracka
+ 44 (0) 20 7620 2947

Photography
Keith Parry
www.keithparry.com
+ 44 (0) 20 8983 0044

P072 – 073
Printworks
www.theprintworks.com
+ 44 (0) 161 653 9401

RTKL
www.rtkl.com
+ 44 (0) 20 7306 0405

Tyco Integrated Systems
www.tyco.com
+ 44 (0) 1223 866 502

Photography
Paul Bock
paulbockphoto@hotmail.com
+ 44 (0) 131 533 6333

P074 – 075
Hello!
www.singtel.com
+ 65 1 800 438 4338

rodneyfitch
www.rodneyfitch.com
+ 44 (0) 20 8743 8244

P076 – 079
Canary Wharf
www.canarywharf.com
+ 44 (0) 20 7418 2000

Kate Henderson
+ 44 (0) 1730 825 115

P082 – 083
Grants
www.grantscentre.com
+ 44 (0) 20 7479 9152

HOK International
www.hok.com
+ 44 (0) 20 7636 2006

P084 – 087
Mulberry
www.mulberry.com
+ 44 (0) 20 7491 3900

Four IV
www.fouriv.com
+ 44 (0) 20 7837 8659

Kate Henderson
+ 44 (0) 1730 825 115

Photography
(P081, 084, 085)
Edmund Sumner
www.edmundsumner.co.uk
+ 44 (0) 20 8871 0914

P088 – 089
Christian Lacroix
www.c-lacroix.com
+ 81 3 5784 3671

Vanceva
www.vanceva.com
www.dhu.be
+ 44 (0) 1633 275 110

Christophe Carpente
www.caps-architects.com

P090 – 091
Harrods
www.harrods.com
+ 44 (0) 20 7730 1234

Minki Balinki
+ 44 (0) 1725 513 412

P092 – 093
Karen Millen
www.karenmillen.com
+ 44 (0) 1622 664 032

Architectural Window Films
+ 44 (0) 20 8441 4545

Brinkworth
www.brinkworth.com
+ 44 (0) 20 7613 5341

Photography
Richard Davies
+ 44 (0) 20 7722 3032

P094 – 095
Perspex
www.perspex.co.uk
+ 44 (0) 1254 874 319

Bobo
+ 44 (0) 1273 400 732

P096 – 097
Issey Miyake
www.isseymiyake.com
+ 33 (0) 1 44 54 07 05

Corian
www.corian.com
+ 44 (0) 800 962 116

Bouroullec
www.bouroullec.com
bouroullec@wanadoo.fr

P099 – 101
Liberty
www.liberty.co.uk
+ 44 (0) 20 7734 1234

Photography
Melvyn Vincent
www.melvynvincent.com
+ 44 (0) 20 7490 4099

P102 – 103
DAKS
www.daks.com
+ 44 (0) 20 7409 4000

Photography
Keith Parry
www.keithparry.com
+ 44 (0) 20 8983 0044

P104 – 105
Selfridges
www.selfridges.com
+ 44 (0) 20 7629 1234

adidas
www.adidas-salomon.com

P108 – 111
Paul Smith
www.paulsmith.co.uk
+ 44 (0) 20 7379 7133

P112 – 115
Louis Vuitton
www.louisvuitton.com
+ 39 (0) 81 08 10 010

Kate Henderson
+ 44 (0) 1730 825 115

Minki Balinki
+ 44 (0) 1725 513 412

P116 – 119
Miss Selfridge
www.arcadiagroup.co.uk
www.missselfridge.co.uk
+ 44 (0) 20 7636 8040

Photography
Michael Taylor
+ 44 (0) 7860 226 300

Photography
(P122: Liberty, London,
P123, 124–5, 126:
Harvey Nichols and
Dickins & Jones)
Edmund Sumner
www.edmundsumner.co.uk
+ 44 (0) 20 8871 0914

(P127)
Angelique Max/David Worthington
www.conrandesigngroup.com
+ 44 (0) 20 7566 4566

(All other images)
The Echo Chamber
www.echochamber.com
+ 44 (0) 20 7203 4867

**P128 – 133
SALES**

Liberty
www.liberty.co.uk
+ 44 (0) 20 7734 1234

Moschino
www.moschino.com
+ 44 (0) 20 7318 0500

Issey Miyake
www.isseymiyake.com
+ 44 (0) 20 7851 4620

Harrods
www.harrods.com
+ 44 (0) 20 7730 1234

Sharpeye
+ 44 (0) 20 7437 7916

Levi's
www.eu.levi.com
+ 44 (0) 20 7292 2500

Diesel
www.diesel.com
+ 44 (0) 20 7497 5543

The Dispensary
www.thedispensary.net
+ 44 (0) 20 7287 8145

Clusaz
+ 44 (0) 20 7359 5596

Fletcher
+ 44 (0) 20 7437 7870

Harvey Nichols
www.harveynichols.com
+ 44 (0) 870 873 3833

**Vital
(Harvey Nichols
windows P123&126)**
www.vitalonline.co.uk
+44 (0)1926 338 811

Fenwick
www.fenwick.co.uk
+ 44 (0) 20 7629 9161

*Photography
(P128 – 133)*
Violet Martini
+ 44 (0) 20 7502 0890

**P134 – 139
9/11**

Photography
Angelique Max/David
Worthington
www.conrandesigngroup.
com
+ 44 (0) 20 7566 4566

**P140 146
MANNEQUINS**

Societa Italiana
www.abcitalia.com
+ 39 03 92 87 32 62

Proportion London
www.proportionlondon.com
+ 44 (0) 20 7251 6943

Pucci
www.ralphpucci.com
+ 1 212 633 0452

DLV
www.dlv-industry.com
+39 0 85 95 05 38

EuroDisplay
www.eurodisplay.de
+ 57 51 40 08 99

New John Nissen
New.john.nissen@
euronet.be
+ 32 27 20 72 03

La Rosa
www.larosaitaly.com
+ 39 0 29 90 44 222

Rootstein
www.rootstein.com
+ 44 (0) 20 7351 1247

Patina V
www.patinav.com
+ 1 626 333 6547

*Photography
(all images except
P140: Proportion
London, P141)*
Violet Martini
+ 44 (0) 20 7502 0890

**P146 – 149
COW PARADE**

The Cow Parade
www.cowparade.net

Liberty
www.liberty.co.uk
+ 44 (0) 20 7734 1234

Chinacraft
www.chinacraft.co.uk
+ 44 (0) 20 7734 4915

Links of London
www.linksoflondon.co.uk
+ 44 (0) 20 7930 0400

*Photography
(P146–7)*
Violet Martini
+ 44 (0) 20 7502 0890

**P150 – 155
COLOR LIGHTING**

Color Kinetics
www.colorkinetics.com
+ 44 (0) 777 928 6472

Saks
www.saksfifthavenue.com
+ 1 212 320 4700

**Martin Professional
Lighting**
www.martin.dk
+ 44 (0) 1622 755 442

Louis Vuitton
www.louisvuitton.com
+ 39 (0) 81 08 10 010

Early Learning Centre
+ 44 (0) 1793 831 300

Into Lighting Design
www.into.co.uk
+ 44 (0) 20 8877 1707

Zumtobel Staff Lighting
www.zumtobelstaff.com
+1 423 237 6666

INDEX